LOST
ST. LOUIS

LOST
ST. LOUIS

VALERIE BATTLE KIENZLE

Published by The History Press
Charleston, SC
www.historypress.net

Copyright © 2017 by Valerie Battle Kienzle
All rights reserved

Front cover: Dozens of steamboats once moored along the Mississippi River wharf at St. Louis. Prior to the arrival of railroads, the river was the major transportation route into and out of St. Louis. *Library of Congress.*
Back cover, top: public domain; *bottom*: Library of Congress.

First published 2017

Manufactured in the United States

ISBN 9781625859242

Library of Congress Control Number: 2017948490

Notice: The information in this book is true and complete to the best of our knowledge. It is offered without guarantee on the part of the author or The History Press. The author and The History Press disclaim all liability in connection with the use of this book.

All rights reserved. No part of this book may be reproduced or transmitted in any form whatsoever without prior written permission from the publisher except in the case of brief quotations embodied in critical articles and reviews.

Dedicated to the memory of the artisans and laborers who built parts of St. Louis that are forever lost.
Dedicated to the memory of the Kienzle, Boedeker and Sanderson families—good Germans with a strong work ethic who loved their adopted home, St. Louis, Missouri, U.S.A.

CONTENTS

Introduction	9
1. Where We Worked: Commercial Structures	25
2. Where We Lived: Residential Structures	52
3. Where We Played: Amusement, Sport and Entertainment Venues	65
4. Where We Ate, Drank and Lodged: Restaurants, Breweries and Accommodations	82
5. How We Traveled: Transportation	93
6. Where We Shopped: Department Stores, Shops and Grocery Stores	102
7. Where We Healed: Hospitals	109
8. Where We Learned: Schools and Education	115
9. Where We Prayed: Houses of Worship	123
10. What We Needed: Services and Necessities	128
Bibliography	139
Index	149
About the Author	157

INTRODUCTION

It is self-evident that St. Louis affected me more deeply than any other environment has ever done. I feel that there is something to having passed one's childhood beside the big river, which is incommunicable to those people who have not. I consider myself fortunate to have been born here, rather than in Boston, or New York, or London.
—*T.S. Eliot, born in St. Louis, September 26, 1888*

Several common themes can be found in a comprehensive history of St. Louis, Missouri: tear down, rebuild and keep moving. Destroy the old to make way for the new and improved. A look at Camille N. Dry and Richard J. Compton's *Pictorial St. Louis, the Great Metropolis of the Mississippi Valley: A Topographical Survey Drawn in Perspective, A.D. 1875* and current Google maps of the same areas show the difference between St. Louis then and St. Louis now. A comparison of the same views reveals how many buildings and residences that once existed no longer do.

St. Louis as it is known today began in February 1764. A small group of Frenchmen from New Orleans with a land grant from the king of France wanted to establish a fur-trading post on the western banks of the Mississippi River a few miles from its confluence with the Missouri River. The location was near the grounds of today's Gateway Arch, but the topography the first French settlers saw looked nothing like it does today. Pierre Laclede, Auguste Chouteau and others claimed the bluff-filled land and named it for French King Louis IX. But they were by no means the first to inhabit the area.

Introduction

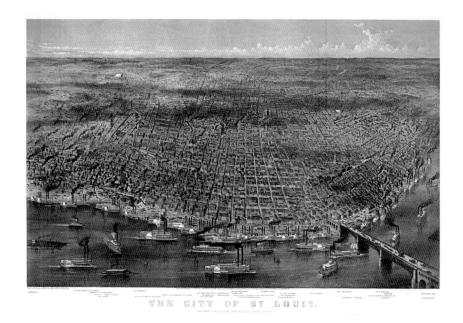

St. Louis founders developed a simple street grid soon after the village was settled. It was not long before the city grew north, south and west from there. *Library of Congress.*

Prior to their arrival, the land along the mighty Mississippi was home to ancient peoples. Evidence of previous civilizations existed in the form of dozens of huge earthen structures thought to be a type of ceremonial mound. Their existence led 1800s riverboat captains to nickname the area "Mound City." There existed in the mid-1800s two schools of thought regarding the mounds. Some thought the mounds were remnants of a long-ago civilization. However, since no evidence of streets or structures remained, there was no reason to preserve the mounds and their contents. Others thought the mounds had formed as natural deposits driven by wind and rain over a long period of time. Some wanted to preserve the mounds and build around them; others favored leveling them in the name of progress. In the end, progress won.

As the city grew and expanded, all but one of the mounds were destroyed. Residences and commercial structures were built. Earth was removed and relocated with little regard to the mounds' original purpose or contents. Thus a new city, St. Louis, was born and came to life in the middle of the United States, near the confluence of three major waterways, the Mississippi, the Missouri and the Illinois Rivers.

Introduction

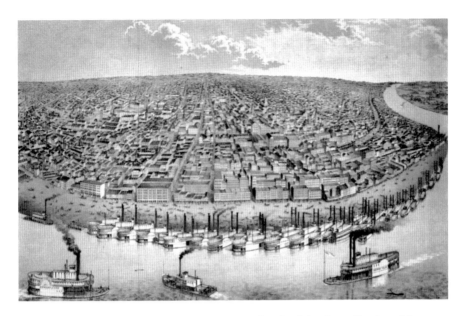

This serene depiction of St. Louis in 1859 is somewhat deceiving. In reality, the mighty Mississippi River bordering the eastern edge of the city is never blue and serene, but brown with a swift current. *Library of Congress.*

At varying times, both France and Spain claimed possession of the land that includes today's St. Louis. Then, in 1803, President Thomas Jefferson negotiated an amazing deal. The United States bought this and more than 530 million acres of land from France in what was called the Louisiana Purchase. The cost: $15 million, or about $0.03 an acre.

Interest in the riverfront village increased following Meriwether Lewis and William Clark's two-year exploration of the Louisiana Purchase territory. Famed explorer Zebulon Pike (Pikes Peak was named for him) was commissioned by the government to explore the Mississippi River in search of its origin. His expeditions in 1805 and 1806 began in St. Louis. The city's location made it a natural crossroads for commerce and growth potential. The tiny fur-trading village was about to grow.

John Fletcher Darby was born in North Carolina in 1803 and moved to St. Louis with his family when he was fifteen. As an adult, he became an influential businessman and statesman. He was elected mayor of St. Louis in 1835 and was subsequently reelected several times. He was an early supporter of building a railroad. In his 1880 book *Personal Reflections of John F. Darby*, he recalls the St. Louis he knew soon after his family moved here:

Introduction

> *But the inhabitants were, beyond doubt, the most happy and contented people that ever lived. They believed in enjoying life. There was a fiddle in every house, and a dance somewhere every night. They were honest, hospitable, confiding, and generous. No man locked his door at night, and the inhabitant slept in security, and soundly, giving himself no concern for the safety of the horse in his stable or of the household good and effects in his habitation.*

St. Louis was incorporated as a city in 1823. North–south and east–west streets were marked. Homes and businesses were established, and common grounds were set aside for farming and pastures. At that time, when tall bluffs overlooked the Mississippi River, no wharf existed alongside the river. Only two landings opened from the forty-foot limestone bluffs to the river, one at the foot of what became Market Street and one at the foot of Oak Street, later called Morgan Street. St. Louis remained a rugged frontier town.

In 1836, author Washington Irving published *Astoria: Or, Enterprise Beyond the Rocky Mountains*. John Jacob Astor, businessman and owner of the American Fur Company, had commissioned Irving to accompany and chronicle his company's 1810–12 expedition to Oregon. The book became a best seller. Irving described St. Louis of the 1810s in chapter 14:

> *St. Louis, which is situated on the right bank of the Mississippi River, a few miles below the mouth of the Missouri, was, at that time, a frontier settlement, and the last fitting-out place for the Indian trade of the Southwest. It possessed a motley population, composed of the creole descendants of the original French colonists; the keen traders from the Atlantic States; the backwoodsmen of Kentucky and Tennessee; the Indians and half-breeds of the prairies; together with a singular aquatic race that had grown up from the navigation of the rivers—the "boatmen of the Mississippi"—who possessed habits, manners, and almost a language, peculiarly their own, and strongly technical. They, at that time, were extremely numerous, and conducted the chief navigation and commerce of the Ohio and the Mississippi, as the voyageurs did of the Canadian waters; but, like them, their consequence and characteristics are rapidly vanishing before the all-pervading intrusion of steamboats. Here were to be seen, about the river banks, the hectoring, extravagant bragging boatmen of the Mississippi, with the gay, grimacing, singing, good-humored Canadian voyageurs. Vagrant Indians, of various tribes, loitered about the streets. Now and then a stark Kentucky hunter, in*

INTRODUCTION

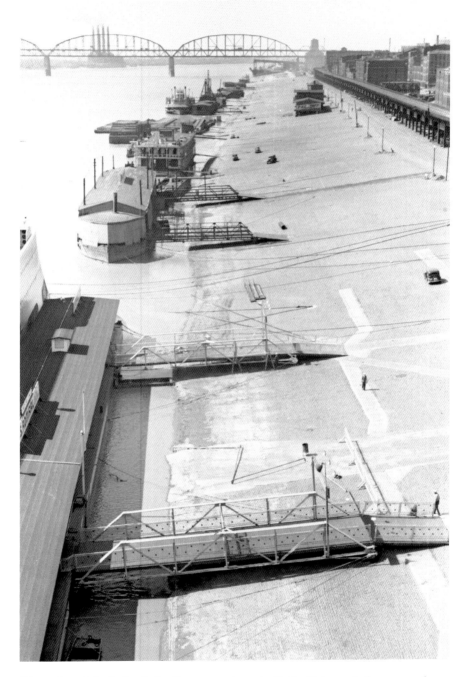

The section of the St. Louis riverfront now adorned with the Gateway Arch was once the heart of the city's thriving business district. *Library of Congress.*

Introduction

> *leathern hunting-dress, with rifle on shoulder and knife in belt, strode along. Here and there were new brick houses and shops, just set up by bustling, driving, and eager men of traffic from the Atlantic States; while, on the other hand, the old French mansions, with open casements, still retained the easy, indolent air of the original colonists; and now and then the scraping of a fiddle, a strain of an ancient French song, or the sound of billiard balls, showed that the happy Gallic turn for gayety and amusement still lingered about the place.*

Jessie Benton Fremont was the daughter of famed Missourian and U.S. senator Thomas Hart Benton. She described aspects of her early life in St. Louis in her 1887 book *Souvenirs of My Time*:

> *Although St. Louis was not more than a petite ville* [small city] *in numbers, yet it had great interests and had a stirring life....Here the tawny swift Mississippi was stirring with busy life, and the little city itself, was animated from its thronged river-bank out through to the Indian camps on the rolling prairie back of the town.*

Soon, immigrants from Europe and other countries heard about the St. Louis area. They came here to flee political and religious oppression and to pursue their dreams of success in a new land. So plentiful were the opportunities in St. Louis that recent arrivals from Germany, Ireland, Italy, Poland and, later, Greece, Serbia, Syria and Lebanon sent glowing praises to family and friends living in the old countries. "Come to St. Louis, Missouri, U.S.A.," they wrote. "The opportunities here are plentiful."

And they came. Tens of thousands of individuals in search of a new life and opportunities arrived here, bringing with them their customs, trades, traditions and artistic skills. In the late nineteenth century, approximately one-third of St. Louis's residents said they were German-born. Soon, the new residents' architectural influences were visible in the varied building styles found throughout the city.

But along with the masses of newcomers came another situation: waste disposal and unclean water supplies. A one-hundred-plus-acre lake-like pond existed south of Market Street near today's Union Station and rail yards. Early residents had built a dam and then a mill there and named it Chouteau's Pond. At one time, it was a serene setting, a place to spend leisure time and to get away from town. Wealthy businessmen built large homes nearby.

Introduction

As the city's population grew, so, too, did commercial development and industry. And the growth generated large quantities of wastewater and sewage, much of which ended up in Chouteau's Pond and the nearby Mississippi River. The placid pond became a cesspool of filth. A cholera outbreak struck St. Louis in 1849, killing more than 4,300 of the city's residents. That same year, a fire destroyed fifteen blocks of buildings and twenty-three steamboats moored at the Mississippi River levee. Connections began to be made between tainted water and the illness. The decision was made in the early 1850s to drain and fill in the pond, thus eliminating a suspected source of contaminated water.

Jessie Benton Fremont described St. Louis's cholera epidemic as follows:

> *Sometimes, in a summer's day you feel, before you see why, a chill in the air. Something has changed; and though the day looks the same its sweetness is gone. So, in the summer I was about eight, this bright careless Saint Louis life seemed to chill over. At first we were only told we were not to go to school. Then, we were to play only with each other in our own grounds and no more little friends visited us or we them. The friends who came to my father on the long gallery were as many as ever, but they and he himself no longer had any pleasant leisure, but were quick and busy in coming and going, and all looked grave. The tears were all the time on Madeleine's [her French nurse] face and constantly she was on her knee telling her beads and praying and sobbing. We saw many, many funerals passing. Our house was on a sloping hill, and we saw to all sides of the square. Then, soon, dray with several coffins piled on jolted fast along the rough street, or a wagon-load of empty coffins would cross another street. Madeleine would run in from the gallery hiding her eyes: 'Ah, Mon Dieu* [My God]*, it is all funerals on every side—C'est le cholera.* [It is the cholera.]*"*

Water purification was nonexistent for many St. Louisans at that time. They simply drink directly from water sources, and cholera thus spread to epidemic levels. Fremont described the water purification method used in her family's upper-class household:

> *All the water was brought in large barrels from the river and poured bucket by bucket, into great jars of red earthenware, some of them five feet high. These jars had their own large cool room paved with glazed red brick and level with the street. The jars of drinking water and for cooking were clarified of the mud of the river by alum and blanched almonds, and*

Introduction

then filtered. So much was needed now that even we children were useful in this sort of work. In that cool dark room the melons used to be kept, but there were no melons or fruit now—we ate only rice and mutton and such simple things.

Fremont married and moved west but occasionally returned to St. Louis to visit. One of her visits happened in 1861. Although the city saw no major battles between Union supporters and Southern sympathizers, St. Louis played an important role in the Civil War. In addition to its transportation advantages, the city was a medical hub, a training center for Union soldiers and a horse replacement area. Fremont said the following about her 1861 visit:

With all my happy memories of Saint Louis, think how hard it was to go back there to the feeling that met us in '61—in the beginning of the war. Everything was changed. There was no life on the river; the many steamboats were laid up at their wharves, their fires out, the singing cheery crews gone—they, empty, swaying idly with the current. As we drove through the deserted streets we saw only closed shutters to warehouses and business places; the wheels and the horses' hoofs echoed loud and harsh as when one drives through the silent streets late in the night. It was a hostile city and showed itself as such.

A historical and commercial review of St. Louis was published in an 1860s city directory. It said in part:

St. Louis, as a manufacturing city, is outstripping all her western competitors. Although comparatively young in this branch of industry, she already ranks as the seventh city in the Union in her manufacturing facilities, and will, in a very short period of time stand in the foremost column. Her commercial, railway, and other advantages, added to the health and remarkable fertility of the surrounding country, and the liberality and public spirit of her inhabitants, is rapidly drawing the attention of capitalists, manufacturers and others, from all quarters of the globe, who seek it as a profitable place for investment, or as a permanent home. None who make St. Louis, a residence, for the employment of capital or otherwise, regret the step, but rejoice that their lines have fallen in pleasant places.

Introduction

In 1876, after much discussion, voters approved a separation of the city of St. Louis and St. Louis County. This became known as a home rule city charter and was the first of its kind in the United States. The division became known locally as The Great Divorce. The city and the county established separate governments, municipal services and taxation rates. The city's current boundaries were established, with officials never imagining that the city would continue to grow and spread outward from the river until its limits were fully occupied. Continued growth then spread from the city of St. Louis to St. Louis County. This decision continues to have repercussions into the second decade of the twenty-first century.

The decades after the Civil War were ones of growth and progress in St. Louis. The years from 1865 to 1900 have been referred to by some as "the "Golden Age of St. Louis." By the end of the nineteenth century, St. Louis was the fourth-largest city in the United States. Some citizens boasted that the city was "the future greatest inland city." J.A. Dacus and James W. Buel, in their 1875 book *A Tour of St. Louis; or, The Inside Life of a Great City*, wrote the following:

> *Architecture in St. Louis has undergone a great change in the last few years, and is rapidly developing into modern and beautiful designs, giving elegance and esthetic effect to the city.*
>
> *On the business thoroughfares a large number of the dingy, dark and gloomy buildings that, but a few years since, compared favorably with the commercial architecture of sister cities at that time, has been removed and replaced with grand commercial palaces, towering to an altitude of eight, nine and ten stories above the sidewalk.*
>
> *They are of the latest styles of architecture, diversified in design, material and construction, from the hands of skillful architects, giving the streets a*

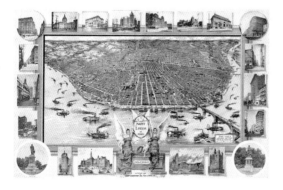

In the late nineteenth century, St. Louis's growing population earned it the designation as the fourth-largest city in the United States. *Library of Congress.*

Introduction

pleasing and picturesque façade, with enough harmony to render the effect grand, and yet enough individuality in the different properties to avoid the monotony so prevalent in nearly all other cities.

In 1904, the world (more exactly, approximately twenty million people) came to St. Louis with the opening of the Louisiana Purchase Exposition. St. Louis had the opportunity to show off for seven months and to boast of the amenities that made it a first-rate city. The Olympic Games and the Democratic National Convention also were held in St. Louis that year, bringing even more attention to the city.

The popularity of the automobile brought a new set of problems to St. Louis as roadways became congested with not only carriages and wagons but also those noisy, engine-powered contraptions. A part of St. Louis history sometimes overlooked is the fact that the city claimed to have the first fuel "filling" station and the first automobile accident.

The city's population peaked by 1950, with more than 850,000 residents. But time marched on, decades passed and trends changed. Younger generations of St. Louisans frowned on the styles of the older generations and continued to build homes farther from the downtown area. Almost all areas of the city had been developed. As a result, rural areas of outlying St. Louis County suddenly became attractive to the thousands of World War II veterans who returned to the area to marry and raise families.

St. Louis's "raze craze" was in place. Civic and business leaders decided that new and different structures were needed to replace what they consider tired, dated and crowded. Victorian styles of any type were out; clean lines and minimal embellishments were in.

Urban flight led to urban blight. Some of the once-beautiful homes and areas fell out of favor. Structures were abandoned, and disrepair set in. As a result, some of St. Louis's architectural heritage and character was lost. In addition, fire and deterioration took their toll on structures, often leaving them unsalvageable.

While many early structures no longer exist, particularly near the downtown riverfront, some remain, thanks in no small part to preservationists and organizations like the Landmarks Association of St. Louis, Inc., and federal tax credits. As a result of their efforts to save architectural treasures of the past, today's residents can see and experience for themselves the intricacies and attention to detail once given to building construction in St. Louis.

Introduction

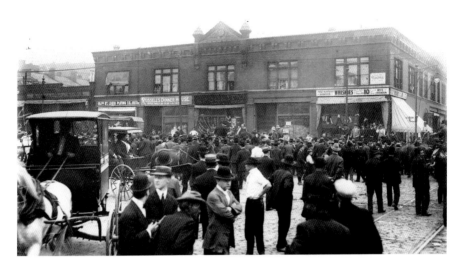

A visit by U.S. president William Howard Taft drew crowds of people and much confusion to the cobblestone streets of downtown St. Louis. *Library of Congress.*

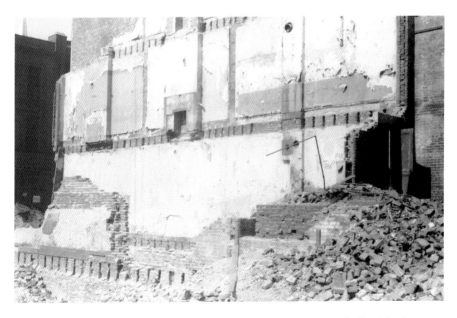

Several historically significant buildings have been razed in downtown St. Louis in the name of civic progress (that is, the construction of parking lots). *Library of Congress.*

Introduction

The St. Louis skyline of 1940 looked much different than it does today. The possibility of a symbolic structure like the Gateway Arch was already being discussed. *Library of Congress.*

The city has no one particular architectural style of its own. Its architecture has been and continues to be a combination of artistic interpretations with multiple variables and influences. Evidence of this can be seen by noting the decorative elements found on both older downtown high-rise buildings and humble one-bedroom bungalows.

In the late nineteenth and early twentieth centuries, many St. Louis commercial buildings were stylized with cast-iron fronts. Several manufacturers of ornamental ironwork were located in the city and shipped products throughout the United States. Buildings from that period with ornate cast-iron façades can still be found in large cities like New York and New Orleans and along small-town Main Streets. However, the buildings in an approximately forty-block area of downtown St. Louis along the Mississippi River, many featuring ornamental ironwork with French Colonial and Creole influences, were destroyed. A massive land clearance project was proposed in the 1930s to make way for the construction of the National Park Service's Jefferson National Expansion Memorial and what became the Gateway Arch. (Actual construction of the park did not begin until the early 1960s.)

Today, the 630-foot stainless steel arch stands as a recognizable symbol of St. Louis's history as the Gateway to the West, but most traces of

Introduction

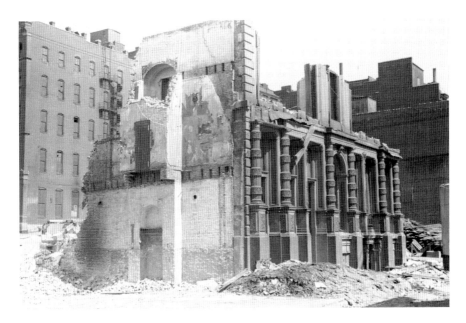

Mid-twentieth-century St. Louis was plagued with a "raze craze." Old buildings were routinely torn down with little regard for historical or architectural significance. *Library of Congress.*

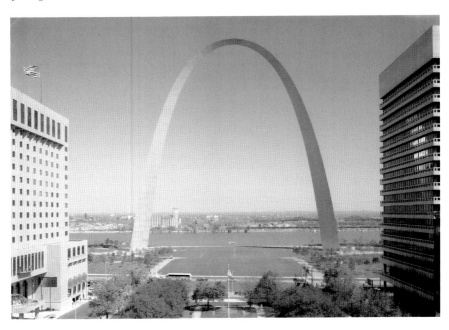

The Gateway Arch, part of the National Park Service's Jefferson National Expansion Memorial, is symbolic of St. Louis's place in history as the Gateway to the West. *Library of Congress.*

Introduction

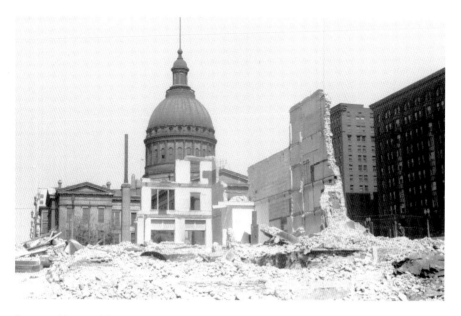

Some architectural features were saved from buildings prior to demolition. St. Louis's City Museum features a collection of rescued and repurposed artifacts. *Library of Congress.*

the city's early architecture are gone. A few later buildings survive that incorporate that era's influences. For some, a true appreciation of the abilities and skills of yesteryear's craftsmen inspires a determination to save the city's remaining architectural jewels for future generations.

Landmarks Association of St. Louis, Inc., was organized in 1958 and incorporated as a nonprofit the following year, at a time when few St. Louisans cared about the history and architectural significance of downtown's unique blend of buildings.

Beginning in the 1970s, the Landmarks Association began a survey to identify significant sites and areas. A few years later, the federal government approved legislation to provide tax credits for renovating properties listed in the National Register of Historic Places. The 1980s arrived, and St. Louis led the nation in historic tax credit reinvestment, no doubt due to Landmarks Association's nominations to the National Register. Landmarks Association also was involved in framing the State of Missouri's 1997 historic rehab tax credit program. Without historic tax credits, once-threatened historic sites might have been destroyed to make room for parking lots. Today, many have been lovingly restored and repurposed.

Introduction

During the later decades of the twentieth century and into the twenty-first century, the St. Louis area experienced another type of loss, that of corporate headquarters and manufacturing centers due to company mergers and overseas production. These losses translated into job losses for thousands of St. Louisans. Companies once headquartered in St. Louis included The Seven-Up Company. While much of this book focuses on physical structures and architecture that have been destroyed, it also takes a look at other aspects of St. Louis that have been "lost," including companies, types of jobs and lifestyles. These pages and images offer a glimpse of the past, of what existed in St. Louis that is no more, of what once was that is now gone. May they remind us that "new and improved" is not necessarily better. Much can be learned from the past.

<div style="text-align: right;">

Valerie Battle Kienzle
St. Louis, Missouri

</div>

1
WHERE WE WORKED

Commercial Structures

It was a cold day in February 1764. Several dozen Frenchmen traveling on the ice-filled Mississippi River came ashore near the grounds of today's Gateway Arch. Led by Pierre Laclede and his stepson Auguste Chouteau, they settled on the terraced riverfront limestone bluffs with one goal in mind: to establish a fur-trading center. The area's proximity to the Mississippi, Missouri and Illinois Rivers made it attractive in terms of transporting fur and other goods and services.

The first order of business was to construct a trading post building and cabins. They laid out a small street grid radiating out from the Mississippi River—three north–south paths intersected by three east–west paths. From these initial blocks and paths, the city expanded. Common grounds were included where villagers could grow crops and raise livestock.

Plentiful forests provided the logs the settlers needed to build homes. They utilized French Colonial building techniques and styles. Some of the early homes incorporated vertical rather than horizontal log placement and limestone. Others featured multi-sided gallery porches designed to take advantage of breezes during the often hot and humid St. Louis summers.

The construction of a house of worship, a mill and a public place also were priorities. The settlement was named for King Louis IX of France and unofficially known as Laclede's Village. By the late 1700s, St. Louis had become an active and important commercial hub. Boats loaded with animal pelts and other marketable products arrived and departed regularly. And people hungry for commercial success noticed. They began moving here from other parts of the United States and from countries across the ocean.

New buildings took shape as more businesses located in the river town. By 1804, the city had grown to almost two hundred houses and more than one thousand people. The arrival of the first steamboats in 1817 greatly improved river transportation and, hence, trade opportunities.

Commerce in St. Louis at that time depended almost entirely on barter and trade, not cash. An early 1800s advertisement in the local newspaper, *Missouri Gazette*, stated merchant John Arthur's terms of business:

> *Cheap Goods.—The subscriber has just opened a quantity of bleached country linen, cotton cloth, cotton and wool cards, German steel, smoothing irons, ladies' silk bonnets, artificial flowers, linen check, muslins, white thread, wool and cotton; a handsome new gig with plated harness; cable and cordelle ropes, with a number of articles which suit this country, which he will sell on very low terms. He will take in pay furs, hides, whiskey, country made sugar and beeswax.*

The 1830s saw the population increase from 6,000 people to more than 16,000. Main (or First) Street became more commercial and less residential in the 1830s. The commercial development in this area continued for about the next ten years. A courthouse had been completed, streets were expanded and improved and establishments like banks and hotels appeared. Later improvements along the river included cutting the plentiful limestone of the existing bluffs into smaller pieces and using the pieces as pavers to improve access along the levee. St. Louis was on its way to becoming a major city.

Disaster struck in May 1849. A steamboat tied up at the levee caught fire. Strong winds quickly carried the flames to almost two dozen moored boats. The wind then carried the fire into the business district, where it quickly spread to the wooden buildings and residences within a fifteen-block area.

Amazingly, the Catholic church building was unharmed. The structure, known locally as the Old Cathedral, remains at this location today on the only piece of downtown St. Louis property still held by its original owner, the Archdiocese of St. Louis. An early blurred daguerreotype image shows the church and its spire standing tall among blocks of rubble and debris.

When the wind finally died down the next morning, more than four hundred structures had been destroyed. Bucket brigades and thin streams of river water had been no match for the advancing flames. Several lives were lost. The extensive damage to the main business section could have been commercially disastrous. Instead, St. Louisans rallied, rebuilt the city with brick and iron and continued to expand.

Lost St. Louis

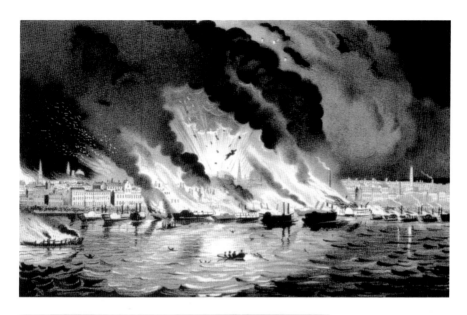

Above: In May 1849, fire broke out on a boat moored at the St. Louis levee. Winds spread the fire, which destroyed fifteen blocks of buildings. *Library of Congress*.

Left: St. Louis was a major producer of bricks, shipping them throughout the country and the world. Repurposed St. Louis–made bricks remain in high demand. *Library of Congress*.

The completion of the Eads Bridge in 1874, the first all-steel bridge across the Mississippi River, brought the railroad to St. Louis, further establishing it as a commercial transportation crossroads. St. Louis, Missouri, U.S.A., was indeed the land of opportunity and possibility.

Fur trading was an important part of the city's commerce for decades as the demand for furs and pelts remained high here and in other countries. By the 1880s, St. Louis's water and railroad access made it one of the top centers for hide trade. In 1886, the volume of hide transactions amounted to more than eighteen million pounds, with pelts and fur coming here from Texas, Arkansas, Colorado, New Mexico, Kansas and other states.

Sugar, corn, wheat, oats, barley, cotton, rye and wool also were important commodities processed and traded through St. Louis. Warehouses and manufacturing facilities were constructed along what came to be called Main Street and the area near the Mississippi River levee. Some St. Louis residents still lived on the upper floors of the buildings where they worked. Others built residences farther south and north of the central business district. The city thrived, and the population grew. South of downtown, iron and steel production were important industries in the city of Carondelet, which became part of St. Louis in 1870.

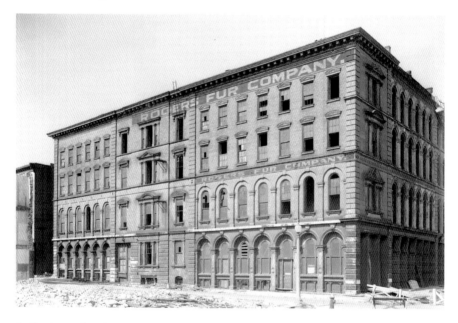

St. Louis was founded as a fur-trading village. Rogers Fur Company was one of many fur-related businesses where pelts were graded before being sold. *Library of Congress.*

When the Eads Bridge opened, trains no longer needed to be ferried across the Mississippi River by boat. The river that once took hours to cross now took minutes. *Library of Congress*.

The mid-1800s saw the arrival of thousands of immigrants, particularly those from Germany, Italy and Ireland, who settled in St. Louis with their dreams of good fortune and new lives. They brought with them their customs, traditions, foods and architectural styles. These newcomers also brought a strong work ethic.

And then an advantageous discovery was made. Clay deposits in a geological feature called Cheltenham syncline were found in abundance under much of southwest St. Louis. The clay was perfect for the production of brick and terra cotta. Soon, the skilled European artisans who now called St. Louis home were creating adornments and enhancing the façades of buildings and houses throughout the city. By the mid-1800s, brick was a dominant building material in St. Louis. Production and technological improvements were such that by the end of the century, St. Louis was the largest producer of bricks in the world.

Specialized touches appeared on St. Louis structures both large and small and included fanciful iron façades, complex brick patterns and terra-cotta adornment. A drive through some of the old city neighborhoods today provides glimpses of such artistic skill on even the humblest of residences. Gifted brick artisans truly left their mark on St. Louis.

Businesses expanded westward beyond the Main Street area, and as they moved, so too did the city's elite. Elaborate residences were built in an exclusive enclave called Lucas Place. Newer commercial buildings were constructed with brick (thought to make them fireproof) and included four and five stories.

The discovery of gold in California in 1849 was commercially and financially advantageous for St. Louis. The city quickly became a supply outpost for thousands of fortune-seekers headed west along the Boone's Lick, Santa Fe and Oregon Trails. The city was, for many, literally the Gateway to the West.

The 1890s saw continued growth in St. Louis. With a population approaching 500,000, St. Louis was the fourth-largest city in the United

Fanciful brick detailing on the Davis-Gaude House at 4931 Page Avenue qualified it as historically significant. Nevertheless, it was razed. *Library of Congress.*

States behind New York, Chicago and Philadelphia. New construction capabilities and trends led to the erection of taller buildings west of the Mississippi River levee.

As St. Louis entered the twentieth century and became a center for the production of boots and shoes, the demand for hides continued. By 1910, the value of furs and pelts traded in St. Louis was put at $9 million. The city had become the world's largest fur-trading market.

But time passed, and with it came changes in tastes, customs and styles. In St. Louis, as in other large established cities, the middle decades of the twentieth century were characterized by a "raze craze." Old structures were torn down and replaced with bigger and "better" buildings farther from the heart of old St. Louis.

In the 1930s, city officials began discussing plans to clear forty blocks of the old downtown St. Louis business district and to relocate some railroad tracks underground. They also wanted to build a magnificent monument recognizing the city's place in history as the gateway to the western United States. Buildings and residences were razed with little or no consideration of their historical or architectural significance. The original sections of St. Louis, with French architectural influences and cast-iron building elements said to rival those of New Orleans and New York, were destroyed. All that remained of the city's early architectural beginnings was the Catholic cathedral (known locally as the Old Cathedral) and the city's nineteenth-century courthouse (the Old Courthouse), the site of the historic Dred Scott decision.

A worldwide contest was announced seeking plans for a unique monument to grace the now-vacant riverfront. Architect Eero Saarinen's plan for an enormous arch was selected in 1948, but the project was delayed due to funding issues. By the time the monument—the 630-foot, stainless steel catenary curve known as the Gateway Arch—was completed in 1965, Saarinen had died.

Lost St. Louis

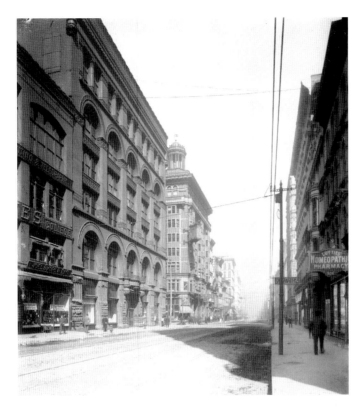

Left: Broadway was and continues to be a major downtown St. Louis thoroughfare. Here it is looking north from Olive Street in the early twentieth century. *Library of Congress.*

Below: The "raze craze" in St. Louis resulted in the demise of numerous downtown buildings. Fortunately, the Old Courthouse was not one of them. *Library of Congress.*

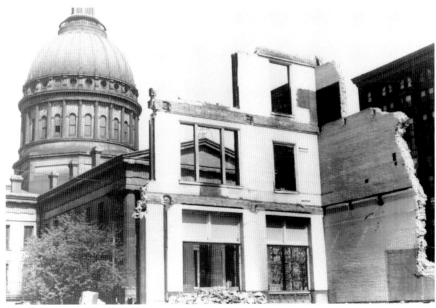

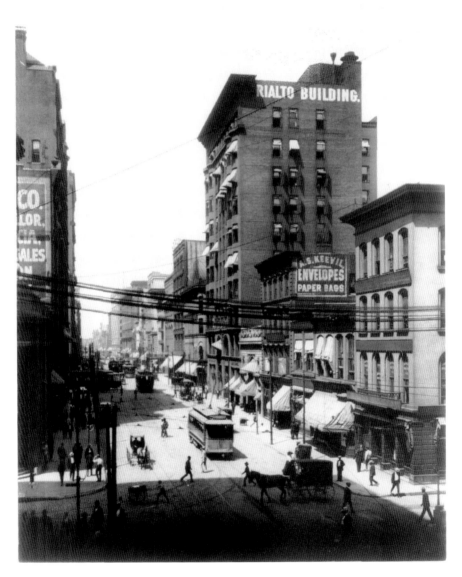

Even before the days of automobiles, downtown streets were crowded and noisy with trollies, horses and wagons, as well as people traveling from place to place. *Library of Congress.*

While numerous commercial buildings (Union Station, the Old Post Office) and residences have been saved and preserved thanks to the tireless efforts of those who recognize beauty in existing structures, much also has been lost in the name of progress. The construction of Interstate 70 in the late 1950s and early 1960s through established neighborhoods resulted in a separation of residences from decades-old schools and churches. Some critics see this action as the beginning of the demise of sections of established Old North St. Louis neighborhoods.

Following are details about some of the unique, historically significant commercial structures that once dotted the St. Louis landscape. Today, they no longer exist. Many were replaced by bigger structures with more modern design features. Others were replaced with parking lots.

A.F. Shapleigh Hardware Company

Augustus Frederick Shapleigh's interest in the hardware business began at age fifteen. A few years later, he was a partner in a hardware company that opened in St. Louis in 1843.

Shapleigh was a successful businessman and innovator, sending a traveling salesman on the road in 1848 and publishing a catalogue of his company's products in 1853. The company sold metal traps and supplies to many who passed through St. Louis on their way west to search for gold. His Diamond Edge tools and cutlery were the first in the nation to be covered by a jobbers' trademark.

Shapleigh Hardware Company's headquarters was located at Washington Avenue and Third and Fourth Streets. The company name was changed several times in its next century in business. It continued operations until the early 1960s. The area where the building stood is near Interstate 70 and the Mansion House complex.

A.W. Fagin Building

The A.W. Fagin Building, located at Olive and Ninth Streets, was a multi-story office building designed by New York architect Charles P. Clark and completed in 1888. Its exterior design broke with traditional form at

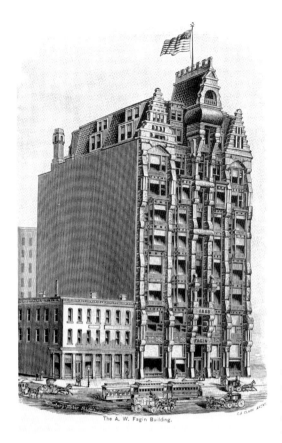

The A.W. Fagin Building broke with traditional design styles of the time. It featured multiple windows and an abundance of natural light. *Public domain.*

that time and featured an abundance of glass to let in natural light. The building was considered by some to be the city's first skyscraper. Described as basically fireproof, the structure was built with steel and featured a deep stone foundation and a red granite façade. It included two elevators, and in case of an emergency, each floor had a fire escape. Remodeling a few years later resulted in a more traditional-looking building and a new name—the Burlington Building. The structure was subsequently razed.

American Brewing Company

St. Louisans like to drink beer. The thousands of Germans who settled in St. Louis in the last half of the nineteenth century brought with them a taste for beer and plenty of recipes for the foamy beverage. As a result, St. Louis

became home to dozens of breweries, including Falstaff Brewery, Lemp Brewery, Hyde Park Brewing, Columbia Brewing, Griesedieck Brothers, Grone Brewing Company, Wilhelm Stumpf Brewery, Schilling & Schneider Brewing Company and Winkelmeyer Brewing Association. A few breweries enjoyed long-term success; most did not.

American Brewing Company (ABC) was founded in 1890 by three members of the Koehler family. They opened the brewery soon after another family brewery, Excelsior Springs, closed. The company's production facilities were located at 2814–24 South Seventh Street. The company specialized in Bohemian and bock beers, and its products were shipped to countries throughout the world, including Egypt, the Philippines and Japan. Like many other U.S. breweries, the company never really recovered after Prohibition. ABC steins and graphic serving trays can still be found for sale by collectors of beer memorabilia.

A.P. Erker & Bro. Opticians

A.P. Erker & Bro. Opticians began business in 1879. It was located at 617 Olive Street and has been a fixture on that busy downtown thoroughfare ever since. It was the first manufacturing optical firm in St. Louis. The company's inventory included all manner of "spectacles," opera and field glasses, telescopes, magic lanterns, stereopticons and artificial eyes. The Erkers also carried blueprint and tracing papers and surveying equipment.

The company is a fifth-generation family-owned enterprise that remains in business. It specializes in luxury and designer eyewear and products manufactured in St. Louis. Erker's Fine Eyewear has several St. Louis locations, including on Olive Street not far from where the company's early office stood.

Belcher Sugar Refinery

St. Louis's river transportation access helped it become a hub for sugar refining. Belcher Sugar and Refining Company was founded in the mid-1800s by members of the Belcher family. The company dealt with all qualities of sugars, syrups and molasses and prided itself in "fair dealing."

A large refining plant was built at O'Fallon and Lewis Streets in 1881. The family ran the business until 1882. In 1886, the company's name was changed to St. Louis Sugar Refining Company. The building complex still existed until part of it burned in 2001. It was subsequently demolished.

BOATMEN'S BANK

Founded in 1847, Boatmen's Savings Institution claimed to be the oldest bank west of the Mississippi River. This was the start of a lengthy history in St. Louis, during which it took pride in "legitimate and safe" banking practices. The name was changed to Boatmen's Bank in 1890 and was engraved in stone on the front of its building at Washington Avenue and Fourth Street. This building was destroyed by fire in 1914. The bank soon rebuilt a larger structure at Broadway and Olive.

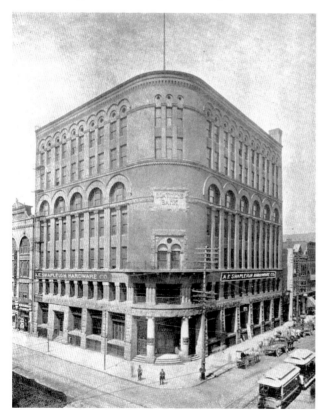

Boatmen's Bank had a lengthy St. Louis history, changing locations as it grew. After it burned in 1914, a larger structure was built at Broadway and Olive Street. *From* Pictorial St. Louis, Past and Present: A Sketch of St. Louis, Its History, Resources, Chronological Events, Tables of Interest.

The Boatmen's Bank organization no longer exists, a victim of the bank mergers of recent years, but the replacement building still exists. This structure, today known as the Marquette Building, is a National Register property.

Century Building & Syndicate Trust Building

The ten-story Century Building was located on Ninth Street near Eighth and Olive Streets and directly across from St. Louis's elaborate U.S. Post Office. Completed in 1896, it contained offices, a theater and retail space and was joined to the Syndicate Trust Building. Together, they were part of one of the city's largest buildings at that time and were an integral part of the downtown business district.

The buildings witnessed decades of St. Louis history before they began to fall out of favor. Leasing rates had dropped dramatically. Plans called for the Old Post Office to be renovated but for the Century Building to be destroyed to make room for a parking facility. In an effort to save the buildings, preservationists secured placement in the National Register of Historic Places. The National Trust for Historic Preservation became involved, initially in favor of saving the structure but later supporting its destruction.

The building was demolished, and its architectural significance was destroyed in 2004. Some preservationists look at the demolition as one of the city's biggest losses.

Express Wagon Assistant

It was the mid-nineteenth century. A man named Alvin Adams saw a need in the Boston area and decided to do something about it. Long before the days of Federal Express and United Parcel Service, Adams began delivering urgent local messages and materials in horse- or mule-drawn wagons. His business was a success. Soon, he expanded his company, Adams Express, to other large cities, including New York, Philadelphia and St. Louis. He utilized rail service and stagecoaches to get items between cities. Older boys were hired as wagon assistants to help with deliveries throughout St. Louis.

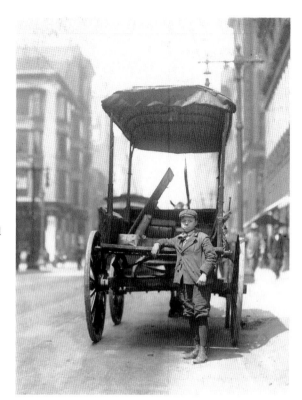

Right: Adams Express Company was a delivery service established in several cities, including St. Louis. School-age boys often were employed to provide speedy service, circa 1910. *Library of Congress*.

Below: Parcel delivery to businesses has been an important part of St. Louis commerce for decades. Young men often were hired for such jobs. *Library of Congress*.

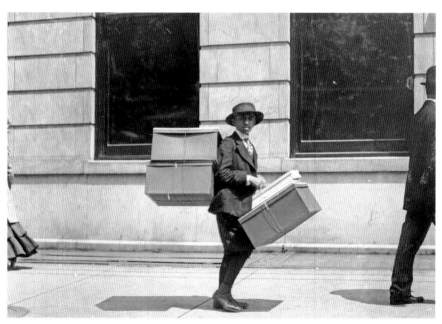

Lost St. Louis

Friedman-Shelby International Shoe Company

In the last half of the nineteenth century, St. Louis's location near rivers and railroads attracted people moving west from crowded East Coast cities. It also attracted business interests and entrepreneurs. As a hub for fur and hide trade, St. Louis was a logical location for boot and shoe production.

The growth of shoe companies centered on Washington Avenue and nearby streets including Twelfth, Thirteenth, Fourteenth and Fifteenth Streets and Lucas Avenue. The area provided convenient transportation access. Soon, footwear production facilities were being built in the area. Friedman-Shelby International Shoe Company was a leader in the industry.

While Friedman-Shelby's building at 1625 Washington Avenue still exists, the company and its footwear lines, like Red Goose Shoes for Children, do not. Generations of adults remember shopping for shoes as children and being greeted with the familiar Red Goose logo. Red Goose shoes were designed specifically for juvenile customers; the shoes were not simply smaller versions of adult styles. Children born in the middle of the twentieth century may remember that with the purchase of the company's shoes, there was the reward of pulling down on the neck of a Red Good statue and getting a golden egg containing a small prize. Successful corporate marketing at its finest!

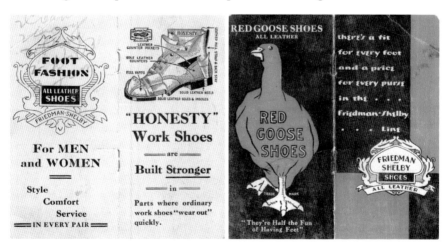

Left: St. Louis became a leader in the footwear industry in the twentieth century. Friedman-Shelby International Shoe Company was one of many located on or near Washington Avenue. *Advertising card, author's collection.*

Right: Red Goose Shoes was the name that St. Louis's Friedman-Shelby International Shoe Company gave to its juvenile footwear line. Generations of children wore Red Goose Shoes. *Advertising card, author's collection.*

Funsten Brothers Fur Auction

St. Louis was founded as a fur-trading village. Its proximity to the transportation opportunities of the Mississippi River made it a popular spot for buying, selling and trading fur. Funsten Brothers Fur Auction was one of many fur-related businesses near the levee. The company promoted itself as the "World's Marketplace for Furs." F.C. Taylor & Co. became the most prominent fur-trading house in St. Louis. Bronson Hide Company, Federal Fur & Wool Company (both started in the mid-nineteenth century) and Abraham Fur Company had warehouses in the area. Other companies included Bobrow Furs, Moser Fur Company, W. Wolfmein Hides and O.F. Jeorling & Son Hides, Furs, Wool.

A "season's catch" was a fur-trading term used to describe the number of furs processed in an area in one year. In 1833, American Fur Company handled approximately 25,000 beaver skins, a top comodity due to the animal's heavy coat. In 1840, the company's season's catch coming through St. Louis included 67,000 buffalo robes or hides. Eight years later, the

St. Louis began as a fur-trading village with three north–south and three east–west streets. This is Main Street before demolition for the Gateway Arch grounds. *Library of Congress*.

season's catch of buffalo and other hides equalled 110,000. Sometimes, a season's catch included furs caught and processed by Native Americans.

Furs popular at the time included pelts from lynx, otters, beavers, mink, muskrats and other animals. Large quantities of pelts were brought to fur warehouses, where they were inspected and graded before being sold for clothing production in the United States and other countries.

HAMILTON-BROWN SHOE FACTORIES

A.D. Brown's Hamilton-Brown & Company was another of the many successful late nineteenth-century footwear companies located in St. Louis. It also established manufacturing facilities in the area. *Shoe & Leather Reporter*, a Boston-based publication devoted to reporting happenings in the footwear industry, logged the following report in its May 1894 edition: "The Hamilton-Brown Shoe Company sold 1,000 cases of rubbers last week.

Early twentieth-century industrial growth resulted in a need for factory workers. Young workers break for lunch on Olive near Nineteenth Streets in 1910. *Library of Congress*.

They are making 3,000 pairs of shoes a day. Their sales for the four months of this year are larger than they were the same time last year. The sales of Brown Shoe Company show a gain this year compared with last. They make men's and women's shoes. Their capacity is 5,000 pairs daily."

At the start of the twentieth century, the company proudly advertised its all-steel offices and showroom at Washington Avenue and Twelfth Street. The company also boasted that its footwear manufacturing facility, located at Locust and Twenty-First Streets, could produce seven thousand pairs of shoes each day.

Hop Alley/Chinatown

In the last half of the nineteenth century, St. Louis's employment opportunities sounded promising to a small group of Chinese natives who had first settled in New York and San Francisco. They moved to an area bordered roughly by Eighth, Walnut and Market Streets in downtown St. Louis. They began businesses, including hand laundries, tea and herb shops, groceries and restaurants. They sustained their small, close-knit community and earned a living by providing services to St. Louis residents outside their community.

As the twentieth century progressed, Chinatown grew and prospered, with several hundred people working and living in the small neighborhood. Although not as sizeable as the Chinese communities found in coastal U.S. cities, the community thrived for many decades. Residents established schools and houses of worship. Locally, the area was called Hop Alley.

Chinatown remained a part of the downtown scene until the early 1960s. City leaders, along with August A. Busch Jr., Anheuser-Busch president and owner of the St. Louis Cardinals baseball team, planned to build a large stadium in the space occupied by Chinatown: Busch Stadium. People living there were told to move. The buildings in the area were then demolished.

St. Louis no longer has a Chinatown area. Members of the city's Chinese American community have been absorbed into neighborhoods throughout the city and remain an important part of its ethnic diversity.

Jack Daniel Distillery

Jack Daniel Distillery was established in the tiny town of Lynchburg, Tennessee, in 1866, but through the years, the country's first registered distillery had several St. Louis connections.

It won a gold medal at the 1904 World's Fair. When Tennessee became "dry" (alcohol production and sales prohibited) in the early twentieth century, the company's master distiller, Jack's nephew Lem Motlow, sought other locations for the production and storage of his amber beverage. St. Louis was one of those locations. Then the nation entered Prohibition in 1920, a status that remained for thirteen years. The distillery was left storing hundreds of barrels of Jack Daniel's whiskey.

The distillery, located near St. Louis University, was guarded, but that did not keep thieves from stealing multiple barrels and cases of the product from the warehouse. No one was arrested for the theft.

The following year more than eight hundred barrels of whiskey were drained through a series of hoses into nearby trucks. The barrels' contents were replaced with water and vinegar. When inspectors came to the distillery a month later to check the product, they discovered the theft. By that time, Motlow no longer owned the stored product.

Suspicion fell on Motlow and several St. Louisans. In 1924, he and his St. Louis acquaintances were indicted in what was called a "whiskey milking case," but Motlow was never tried. Prohibition was repealed in 1933. St. Louisans rejoiced, and Jack Daniel Distillery left St. Louis forever to return to its home in Lynchburg, Tennessee.

Judge & Dolph Drug Company

Judge & Dolph Pharmaceutical Company was located in two storefronts on South Fourth Street in 1870.

By the early years of the twentieth century, the company's name had been changed to Judge & Dolph Drug Store. It occupied part of the A.S. Aloe Company Building at 515 Olive Street. In an advertisement in the January 1, 1904 edition of *St. Louis World Fair*, the company boasts of the caliber of its customers but says nothing about the products and services it offers:

The leading drug store of St. Louis is of necessity the one which successfully caters to the best people of the city. There is only one such—only one which, by the completeness and superior quality of its stock and by its excellent management, commands recognition from the Medical Profession and the discriminating element of the laity—that one is without saying Judge & Dolph Drug Co.

Several years later, the company placed small advertisements for an early feminine hygiene product in a local newspaper. And then the company disappeared from the St. Louis business scene. The building at 515 Olive was demolished. An office building was constructed on the site in 1962. The building has been repurposed for residential living.

Lion Gas Building/*Lindy Squared*

Mention the name Charles Lindbergh, and most St. Louisans think of two things: his 1927 nonstop flight from New York to Paris in a tiny airplane named the *Spirit of St. Louis* and a street named for him that runs for miles between north and southwest St. Louis County. Those who lived in St. Louis from 1977 until 1981 may associate Lindbergh with one more thing: a unique mural of the young aviator's face greeting visitors to downtown St. Louis.

For four short years, *Lindy Squared* (measuring approximately forty feet by sixty feet) graced a wall of the old Lion Gas Building at Ninth and Chestnut Streets. The mural commemorated the fiftieth anniversary of Lindbergh's historic flight. Two artists used more than seventy shades of gray painted into more than 1,100 blocks to create the mural.

And then a wrecking ball attacked his visage, destroying a unique piece of St. Louis's urban art. Southwestern Bell's new headquarters building needed the space occupied by the old building.

A scaled-down version of the mural was placed in downtown's St. Louis Centre in 1985. Talk has circulated about re-creating a large-scale *Lindy Squared* and creating additional wall murals. So far, a larger Lindy hasn't reappeared.

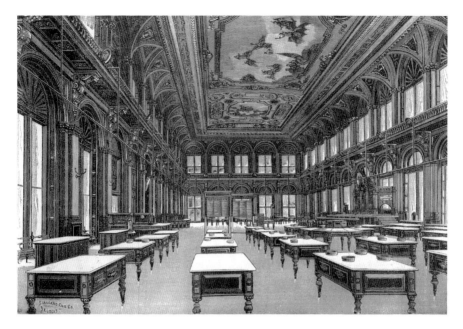

The Merchants' Exchange Building's Grand Hall featured lavish ceiling art, arched windows and an abundance of architectural detail. *Public domain.*

Merchants' Exchange Building

The Merchants' Exchange (also called the Board of Trade of St. Louis) began in the first half of the nineteenth century as a pro-business commercial organization much like a chamber of commerce. Goals of the exchange were to help local businesses monitor trade, commodities and transportation; lobby for legislation on a state and federal level; and generally promote local business interests. The Merchants' Exchange Building was constructed at Third, Pine and Chestnut Streets in 1857.

A large and lavish second Merchants' Exchange Building was constructed on the same site and opened in 1875. The Democratic Convention came to St. Louis in 1876 and used the building's facilities. By 1892, the exchange had more than three thousand members.

The building remained at this location until 1958. Although deemed architecturally significant by historians and experts who worked to preserve it, it was removed to make room for a parking lot and, later, the Adam's Mark Hotel, now known as the Hyatt Regency St. Louis at the Arch.

Mermod & Jaccard Jewelry Company

Mermod & Jaccard Jewelry Company was located at the corner of Broadway and Locust Street in the later part of the nineteenth century. It billed itself as "the grandest jewelry establishment in the world," with hundreds of items in its catalogues and an inventory of fine jewelry, sterling and silver-plate flatware and serving pieces, clocks, watches and custom-designed products.

The company's beginnings can be traced to the early days of St. Louis, when two independent jewelers formed a partnership. It remained an active part of the St. Louis business community for decades despite various partner and name changes. In mid-December 1897, the company's impressive building burned. Half of the company's stock had been placed in two large vaults and was saved. The remainder was destroyed along with the building. The company rebuilt and, in 1904, designed and produced awards for the 1904 Olympic Games. It also produced souvenir items commemorating the 1904 Louisiana Purchase Exposition.

Missouri Pacific Railroad/Buder Building

The arrival in St. Louis of a growing railroad presence led to a decline in the importance of river transportation. With its location near the center of the nation, St. Louis became a railroad crossroads. At one time, more than twenty rail companies provided service to and from St. Louis. Railways leading into and out of the city carried goods, services and passengers to all parts of the country.

In 1902, work was completed on an ornate, terra-cotta, thirteen-story building at Market and Seventh Streets, the Missouri Pacific Railroad's corporate headquarters. When the railroad later moved out, the Buder Building became an office building.

The structure was one of several architecturally significant buildings razed for the construction of the Gateway Mall, a downtown clearance and beautification project designed to provide enhanced and unimpeded views of the Gateway Arch. The building was still occupied by tenants at that time. Preservationists fought to save the building, but it was destroyed in 1984. Some remnants salvaged from the Buder Building now reside at St. Louis's City Museum, a former warehouse that is now an indoor playground filled with repurposed architectural castoffs from some of the city's lost structures.

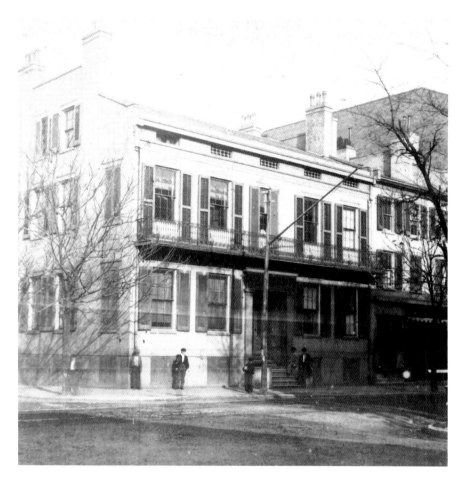

St. Louis became a railroad hub due to its central geographic location. This early Missouri Pacific Railroad building was ornately decorated with terra-cotta embellishments. *Library of Congress.*

MULLANPHY SAVINGS BANK

Mullanphy Savings Bank was established in 1873 and operated at the corner of Broadway and Cass Avenue. It failed at the end of February 1897 following a run on the bank. The local banking association did not aid Mullanphy at that time. Therefore, the bank's depositors lost most or all of their money.

Mullanphy's downfall was the first St. Louis bank failure in ten years. An article in the *New York Times* said that the bank had never fully recovered from the nationwide panic of 1893.

Newsboys

In the days before child labor laws, in a city filled with extended immigrant families with little income, it was not unusual to see children as young as four and five years old at work in the streets and in factories. School attendance was not necessarily a priority if some extra money could be made to support the family.

The use of young boys to sell or hawk the latest newspaper editions was a common sight in St. Louis and in other large cities. St. Louis had multiple English- and German-language newspapers, so the newsboys, or newsies, found plenty of work. Newspapers like the *St. Louis Post-Dispatch* had neighborhood drop-off locations around the city where stacks of newspapers were delivered. The newsies then roamed the streets and sidewalks, calling out the latest headlines. Their goal was to sell as many newspapers as possible. Some had excellent sales skills, cultivated by observing an older brother or neighbor at work. Some newsies worked the streets for years, developing a hierarchy among themselves.

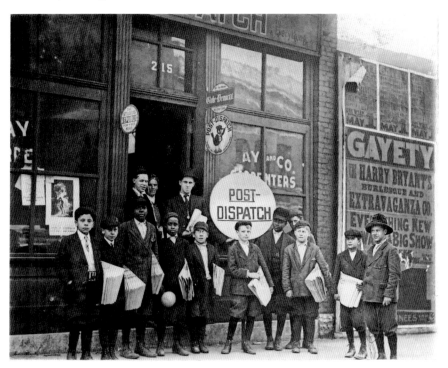

The *St. Louis Post-Dispatch* had branch offices throughout the city. Newsboys picked up newspapers to sell at locations like this at Eighteenth and Olive Streets. *Library of Congress.*

Late nineteenth-century and early twentieth-century newsboys, or "newsies," roamed the streets of St. Louis selling daily newspapers. Some began working at age five. *Library of Congress.*

The dawning of the twentieth century brought government attention to issues like food safety and child labor. Photographer Lewis Wickes Hine was hired by the National Child Labor Committee to document child exploitation in the U.S. labor force. He spent four years (1908–12) traveling the country, visiting cities large and small in order to visually document working children. During his visits to Missouri, he chronicled the many St. Louis newsies working the daytime streets. He also visited small towns in Missouri, where he found children working in factories alongside adults. The Library of Congress has preserved Hine's sometimes startling images of working children.

Prufrock-Litton Furniture Company

The nineteenth-century marriage of Harry F. Prufrock and Roberta Litton resulted in the merger of two furniture companies into one, Prufrock-

Litton Furniture Company, located at Fourth and St. Charles Streets. The company's advertisements in the early years of the twentieth century included colorful wall calendars and penny postcards. The company advertised itself as "The Block of Fine Furniture." Advertising copy on a hand-addressed 1912 postcard stated:

> *The reposeful four-poster bed, and the room with its cheerful hangings of old-fashioned flower-be-sprinkled chintz, and doesn't the suggestion of the trundle bed in the corner bring to memory thoughts of the days so long a-gone? Ah, well—likely you'll be house-cleaning this month, or at least before Easter. Won't you, then give us an opportunity to show you what new dressers, chiffoniers, or other furniture pieces you may need? Rich quality—at the very lowest prices—has made our business what it is.*

Poet, playwright and critic T.S. Eliot was born in St. Louis in 1888 and spent his youth here. It is thought that the name of his first professionally published poem, "The Love Song of J. Alfred Prufrock," was inspired by the name of the furniture company. The firm no longer exists.

R.L. Rosebrough Sons' Marble and Granite Works

R.L. Rosebrough Sons' Marble and Granite Works was established before the Civil War. It was located at 1421 Broadway between O'Fallon Street and Cass Avenue.

Businesses like Rosebrough's had a ready supply of stone with which to work. There was no shortage. A survey of building stones and geology available in the state of Missouri in 1880 revealed that there were twenty quarries located in the city of St. Louis. Additional quarries were located throughout Missouri.

The company created monuments here and shipped them to other parts of the country. From 1926 to 1932, the company was located at Olive Street. Today, the company operates as Rosebrough Monuments with two locations north and south of St. Louis.

St. Louis Dairy Company

St. Louis Dairy Company was located at the corner of Chestnut and Twentieth Streets in a building constructed in 1896. It made several products at the processing plant located there. In 1952, the company's name changed to Sealtest Foods. The company continued operations at that location until a move in the late 1970s. The building was demolished in 1992.

St. Louis Levee

The levee along the Mississippi River was for decades the heart and soul of St. Louis. It was here, along the superhighway of the nineteenth century, that essential goods and services arrived from or were shipped to outlying markets. It was the hub of commercial and business St. Louis.

St. Louis Mutual Life Insurance Building

The St. Louis Mutual Life Insurance Building, known at different times as the Equitable Building and the St. Louis Life Insurance Company Building, was built at Locust and Sixth Streets in 1871. The building's somewhat unusual decorative embellishments included a series of statues along the roofline. The statues had been produced for inclusion on the 1874 Eads Bridge across the Mississippi River but were never installed there.

The cherub-like statues maintained their rooftop vigil for about fifteen years before they were removed. Later views of the building show no sign of the statues.

2

WHERE WE LIVED

Residential Structures

Pierre Laclede drew plans for the original layout of the village that came to be St. Louis. His stepson Auguste Chouteau laid out the village with three streets running parallel to the Mississippi River (First, Second and Third Streets). Cherry Street (now called Franklin Avenue) was the northern boundary. Poplar Street was the southern boundary. The village plat was divided into forty-nine squares. Fifteen squares faced the river. The land between Main and Second Streets contained nineteen squares. The land between what became Second and Third Streets contained fifteen squares. Squares were set aside for a church, a government house and public space. And so St. Louis was born.

Homes constructed in St. Louis's early days had a strong French influence. The most common styles were the vertical-log construction frame homes, built on rock foundations, and rock-only houses. Rock houses were expensive to build and usually were occupied by extremely wealthy individuals. St. Louis's first church was constructed with vertical logs.

French-style home construction fell out of favor after the first brick home was constructed in 1813. Multistoried townhouses or terraced houses were popular choices for wealthy St. Louisans in the mid-1800s. Working-class residents lived in multifamily tenements; long, narrow residences called shotgun houses; and angular, narrow homes with front doors often on one side. Many early St. Louisans conducted business in their homes.

A ready supply of naturally occurring brick clay led to St. Louis becoming a world leader in brick production. Brick became a popular

A type of clay called Cheltenham syncline was discovered underneath much of southwest St. Louis. The clay was ideal for brick and tile production. *Library of Congress*.

building material and was used throughout the city to construct houses, commercial buildings and warehouses.

As the nineteenth century progressed, Victorian-style homes and "private places" became popular choices for wealthy St. Louisans who wished to close themselves away from the dirt, noise and crowds of the city. Large mansions built in the private enclaves featured an assortment of architectural styles and flourishes. Landscapes, gardens and public parks became popular attractions as people became interested in the outdoors.

Residential development continued to move west in the early decades of the twentieth century. Large and lavish apartment buildings were constructed near Forest Park, the crown jewel of St. Louis's public places. Two- and four-family flats were built throughout the city by working-class individuals. A family could live in part of the flat and rent out other parts, thus helping to pay off mortgages and, hopefully, earn some extra money.

A unique housing style, flounder, became popular in 1870s St. Louis. These tall, thin structures look like half-houses—to some people, they

Wealthy nineteenth-century businessman Henry Shaw bought land and began what today is known as the Missouri Botanical Garden. This observatory once stood there. *Library of Congress.*

resembled a type of fish called flounder—with one side wall standing higher than the other. The main entrance door usually opens not from the narrow front but from one of the structure's long sides. A few flounder-style houses still exist in St. Louis.

The Historic American Buildings Survey (HABS) was started in 1933 to document the country's architectural heritage. It was the nation's first federal preservation effort. Several St. Louis structures were included in the survey (indicated herein by "HABS"). Some were mansions; others were comfortable homes. According to the survey's selection guidelines, "the building selection ranges in type and style from the monumental and architect-designed to the utilitarian and vernacular, including a sampling of our nation's vast array of regionally and ethnically derived building traditions." The survey included photographs and details about each property. Many of the St. Louis houses described in the survey ultimately were demolished, their unique and/or unusual details lost in the destruction.

Midcentury St. Louis homes constructed during the ongoing expansion west featured clean lines and little architectural ornamentation. The lavish mansions lost their appeal and monetary value. Many were divided into rooming houses. Others fell into disrepair and were razed. Only in recent decades has the faded glory been restored to some of these century-old treasures.

Following are the stories behind some of St. Louis's demolished houses. These structures sheltered families and witnessed daily life in a large midwestern city. Some were heralded as architectural marvels. Others simply provided protection from harsh weather and the outside world. In the end, each one became nothing more than a pile of rubble.

Adolphus Meier House (HABS)

The Adolphus Meier House was one of several homes in the 4900 block of Page Avenue that were included in the HABS survey. Unlike homes on St. Louis's private streets, these were not mansions or elegantly appointed, but some of the details and embellishments found on these modest abodes made them architecturally significant.

Although the Adolphus Meier House and other St. Louis residences were photographed and their unique characteristics catalogued in the Historic American Buildings Survey (HABS), preservation efforts were weak. The "raze case"—tear down the old, build the new—was strong in the city at that time. The Adolphus Meier House and others were eventually razed.

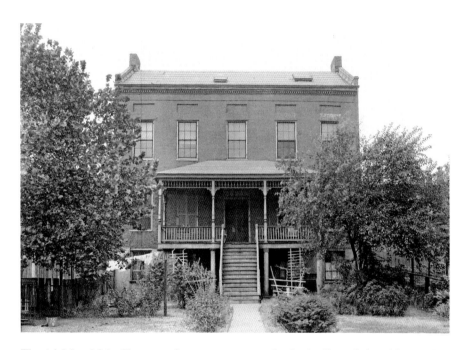

The Adolphus Meier House was by no means ornate, but its details made it architecturally significant. It, however, was demolished. *Library of Congress*.

Blossom House (HABS)

Chalmers Blossom was a financially successful riverboat captain during the Mississippi River's boom years before the arrival in St. Louis of the railroads. He was also a successful businessman. He had an expansive home built for his wife and family on what at the time was rural land. The area later experienced residential growth and became known as the Central West End. The house was located on what later became Union Boulevard near Enright.

Blossom retired to his estate and continued to live there until his death in 1903. His wife and family members occupied the house until 1929. It sat empty during the years of the Great Depression. Like the Meier and Walsh houses mentioned in this text, the Blossom House was included in the Historic American Buildings Survey (HABS), the nation's first federal preservation effort, begun in 1933. Although the house had been labeled as an architecturally significant structure, it was razed in 1942.

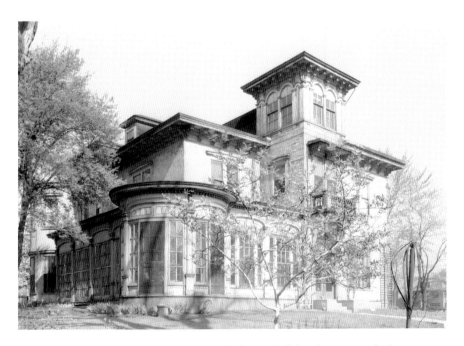

Chalmers Blossom's house was one of the early homes built in what came to be known as St. Louis's Central West End. It was razed. *Library of Congress.*

Colonel Charles S. Hills House

Charles S. Hills earned a name for himself during the Civil War. He moved to St. Louis after the war and became a successful businessman, making much of his fortune in the tobacco industry. He spared no expense in making the home he had built at 5065 Lindell Boulevard an extravagant show place. Architectural details, rich wood and dramatic artistic flourishes were seen both inside and outside the house.

Hills died in 1902 with no children. His wife lived there until her death in the 1920s. The beautiful mansion was demolished in 1939 to save money on taxes. It was not the first St. Louis mansion to meet such a fate following the tough years of the Great Depression.

Cracker Castle

The ornate mid-nineteenth-century brick mansion dubbed the Cracker Castle was located on Chouteau Avenue and St. Ange Lane. The home's owner, Jonathan O. Pierce, was a partner in a St. Louis cracker company that scored a contract to provide hardtack crackers to the Union army during the Civil War. He became a wealthy man as a result.

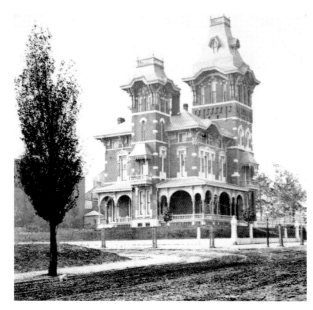

The Cracker Castle got its nickname because its owner made a fortune selling hard-tack crackers to the Union army during the Civil War. *Library of Congress.*

The unique structure was designed to impress, incorporating what seemed to some visitors an endless number of rooms and extravagant architectural and decorative embellishments. When the war ended, so did the need for large quantities of hardtack crackers. The house was sold twice before it met its demise during a massive spring tornado that hit St. Louis in May 1896. The mansion was too extensively damaged to be repaired.

Edward/Julius Walsh Home (HABS)

An architecturally detailed mansion was built at 2721 Pine Street in the first half of the nineteenth century. Other upscale homes were located nearby. The home was sold soon after its construction to successful St. Louis businessman Edward Walsh. He died in the mid-1860s and left the house to his son Julius. Julius Walsh lived there for almost twenty years.

Time passed. In 1886, the structure became home to the private University Club. The club remained there for ten years. The house was next used by a political club and later a local Catholic organization.

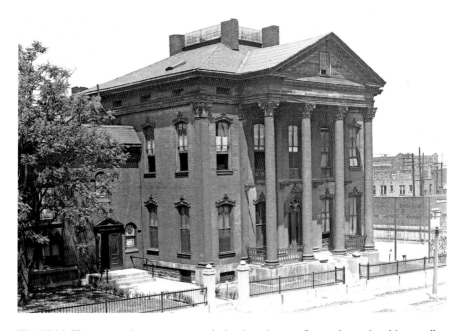

The Walsh Home served many purposes during its existence. It was deemed architecturally significant, but it was a victim of St. Louis's "raze craze." *Library of Congress*.

Although the Walsh home was deemed architecturally important and was included in the Historic American Buildings Survey, it was razed in 1951. Other St. Louis residential structures described in the HABS survey met the same fate during the city's unofficial "raze craze" era.

George D. Barnard Residence

George Barnard was a successful nineteenth-century St. Louis businessman with interests in office equipment, office fixtures, printing and lithography. He served as president of the Merchants' Exchange and was one of the original promoters of the Louisiana Purchase Exposition, the 1904 World's Fair. In 1905, St. Louis Skin and Cancer Hospital was renamed the Barnard Free Skin and Cancer Hospital after he donated money for the construction of its new building. The hospital was dedicated to the study and no-charge treatment of cancer and skin diseases.

Barnard chose architecture firm Tully & Clark to design his expansive brick home, complete with a castle-like turret. The home was constructed in St. Louis's Vandeventer Place, the private-place enclave popular with the city's elite. Photographs of the interior and exterior of Barnard's home were featured in the May 10, 1890 issue of *American Architect* magazine.

Barnard left a $2 million fortune when he died in 1915. His house, as well as all houses in Vandeventer Place, eventually was razed.

Kingsbury Place

Kingsbury Place was one of the private places developed in the early years of the twentieth century, within several years of the 1904 World's Fair. Most of the expansive, well-appointed homes there weathered the Great Depression and war years, but some did not.

The house at 7 Kingsbury Place was the first to be built in the enclave. It featured three stories, twenty rooms and artistic exterior decorative embellishments. Construction was completed in 1902. The house was offered for sale in 1929 and remained on the market until 1941. At that time, with still no potential purchaser in sight, the house was razed. It was one of only a few in Kingsbury Place to meet such a fate.

Several vacant lots in Kingsbury Place were purchased and had homes built on them in the last half of the twentieth century. By the 1960s, the crime and urban blight found outside the confines of Kingsbury Place began to take its toll inside, as well. Residents moved out and relocated farther west. By the 1970s, renewed interest in the old mansions brought a new generation of professionals and young families to the area. The remaining homes have been lovingly restored to their former splendor.

Lucas Place (Before the Civil War)

As the city of St. Louis grew, so, too, did the city's population of successful entrepreneurs. Lucas Place was established prior to the Civil War as a quiet residential enclave for wealthy businessmen and their families. It encompassed a section of street bordered by Thirteenth Street on the east and Eighteenth Street on the west. The large elegant townhouses, mansions and accompanying outbuildings of St. Louis's elite lined the streets.

Robert G. Campbell was one of those who chose Lucas Place for his residence. Campbell was a wealthy businessman with several successful ventures, including the popular Southern Hotel. His family's house was the first to be built in Lucas Place, in 1851. Here, he and his wife entertained wealthy and famous individuals, including President Ulysses S. Grant and his wife, Julia.

Today, the Campbell House sits surrounded by commercial buildings. It is all that remains of the Lucas Place development, which fell out of favor as residential life continued to move west. The street named Lucas Place became Locust Street. The house that once belonged to Robert Campbell and his family has been described as one of the best-preserved nineteenth-century buildings in St. Louis. It operates today as the Campbell House Museum.

Lucas Place, Giles Filley Home

Giles Filley arrived in St. Louis at a time when the population and industry were growing exponentially. In 1849, the same year as St. Louis's destructive downtown fire and the cholera epidemic, he established a company,

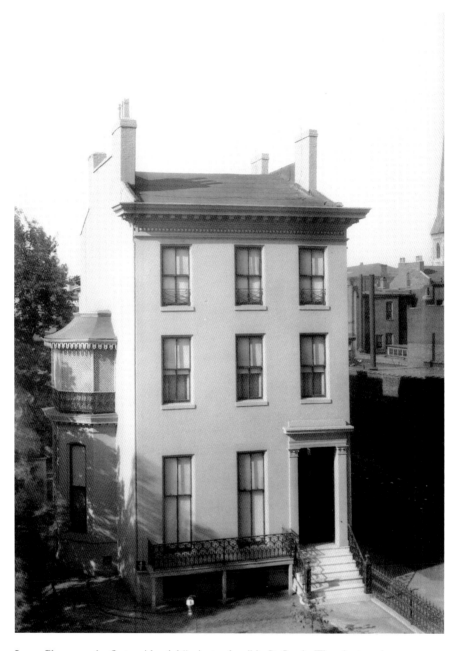

Lucas Place was the first residential "private place" in St. Louis. The nineteenth-century Campbell House is all that remains of this elite neighborhood. *Library of Congress*.

Charter Oak Stove and Range Company. The firm manufactured stoves and accessories like hollowware, tin plates, grates, rivets and other related products. It also manufactured cast-iron cookware. St. Louis was flooded with individuals heading west in search of California gold. They needed supplies, and Filley's firm could fulfill many of their needs.

His company quickly became successful, making Filley a wealthy man. The company name was changed to Excelsior Stove Works and then Excelsior Stove and Manufacturing Company. Its large production facility was located near the Mississippi River, ideal for the shipment of his products by boat to other locales. This was prior to the arrival of railroads in St. Louis. The company continued to grow during the next few decades, becoming the largest manufacturer of stoves in the United States.

St. Louis's first elite enclave was Lucas Place. It was here that a wealthy Filley decided to have a lavish home constructed for his family.

Portland Place

Portland Place was another of the St. Louis elite's Julius Pitzman–designed residential private places. Unlike some of the other private-place developments, Portland Place survived the Great Depression years fairly intact. Strict residential indenture covenants and minimum construction requirements helped the area maintain uniformity.

Only three Portland Place houses were razed. In recent years, the enclave has been rediscovered and its grand houses restored to their former beauty.

Vandeventer Place

As St. Louis grew in the mid-nineteenth century, so, too, did the noise and pollution of the busy riverfront city. Wealthy families began to look for quiet places to live, places away from the commercial hub of the city. For the second time, the elite attempted to isolate themselves from the noise and dirty industrial conditions caused sometimes by their own companies.

In 1870, a tract of land west of the downtown area was owned by the Vandeventer family. It was bounded by Grand, Vandeventer, Enright and Bell Avenues and was once part of the city's common fields, where crops

were raised and livestock grazed. Three St. Louisans with a vision for a new residential development purchased the land. They planned a private place with large, embellished homes, a place where they and their families could shut out the city and live in a pastoral setting. The enclave was named Vandeventer Place.

Vandeventer Place was designed and developed by Julius Pitzman as a private residential street. Pitzman popularized the concept of private streets in St. Louis, designing additional private streets in areas like Compton Heights and Washington Terrace.

Vandeventer Place became a haven for St. Louis's elite population. It was the private enclave where eighty-six of the city's most successful businessmen chose to live. Here, they could build mansions to attest to their business success, raise their families and seclude themselves from crowded, dirty city streets.

Vandeventer Place included lavish landscaping and strict rules governing the homes' exterior appearance and structure. It was here that St. Louis's best architects pulled out all the stops regarding elaborate designs and details. Double-digit bedrooms, Tiffany glass, ballrooms and servants' quarters were the norm.

Several factors contributed to the eventual demise of Vandeventer Place. The city's rapid growth continued westward. By the early twentieth century, commercial and industrial operations were being built on all sides of the enclave, and with them came related pollution and traffic. New private-place developments by Pitzman and others were attracting people to places like the Central West End. As the twentieth century progressed, some original owners died and others found that the mansions were expensive to maintain.

Unpaid taxes and the Great Depression led to the further demise of the once opulent area. The solution, for some, was to raze the houses. By the end of World War II, only about three dozen mansions remained. Then, part of the land was selected as the site for a veterans' hospital. By the end of the 1950s, the remaining homes were destroyed. Vandeventer Place was no more.

An elaborate gate was saved from Vandeventer Place and permanently installed in Forest Park.

Vandeventer Place, Charles H. Peck Home

Charles H. Peck was one of the three successful St. Louis businessmen who purchased the land for the development of Vandeventer Place. His 1871 home was designed by famed architect George I. Barnett and was the first to be built in the enclave. Its expansive three-story proportions and outbuildings stood as a testament to his success. He lived in the house until his death in 1899.

By the mid-twentieth century, the mansion and its remaining neighbors had fallen into disrepair. The decision was made in the late 1950s to raze the remaining houses in Vandeventer Place. Charles Peck's mansion was one of the last to be destroyed.

Westmoreland Place

The elite of St. Louis continued the move west in the late nineteenth century, and private streets remained popular choices. Westmoreland Place was one of the new exclusive Julius Pitzman developments, where the homes were designed by renowned architects. The structures became bigger, better and more ornate, evidence of their owners' business and financial successes. And the new developments were close to what became known as Forest Park. Their proximity to the park would help, to a certain degree, keep future city expansion from negatively impacting home values. The area became known as the Central West End.

However, in the twentieth century, St. Louisans experienced things like the Great Depression and two world wars, and these large homes fell out of favor. Original owners died, and buyers could not be found for these residential marvels. Tough economic times made paying taxes difficult for some. Six Westmoreland Place homes were demolished because the owners could not sell them and could not afford to pay taxes on them. Others remained "white elephants" into the 1950s and '60s. In 1950, three more mansions here were demolished. By 1961, two more had been taken down.

Photographs of some of the lost structures show intricately detailed interiors and extensive use of stone and marble. Finally, in the late 1970s and early 1980s, renewed interest in these majestic homes emerged. Preservation rather than demolition became a priority. Today, these homes' faded beauty has been restored. Newer homes now occupy some of the lots where the older homes once existed.

3
WHERE WE PLAYED

Amusement, Sport and Entertainment Venues

St. Louis was built by people who were not afraid to work. A city that became the fourth largest in the United States by the end of the nineteenth century did not reach that pinnacle without hard work. Utilizing the power of the Mississippi River, becoming a hub of train transportation and growing a strong business and industrial backbone took the efforts of a population with a strong work ethic.

St. Louisans also loved to play. Recreation, sporting events and entertainment were the rewards for their labors. Through the years, St. Louis has been home to an assortment of theaters, athletic teams, entertainment venues and gathering spots. Time passes. New entertainment opportunities replace old ones that have lost their appeal. Some new amusement idea or opportunity is just around the corner, waiting to be discovered. Here are details about a few places of play from the past.

AMBASSADOR THEATER

The Ambassador was built as a movie theater at the corner of Seventh and Locust Streets. It opened in 1926 with an opulence and grandeur unlike any other local theater, and St. Louisans were anxious to see the new moving-picture palace. More than three thousand people attended the theater's opening night. Musical accompaniment was provided by a massive one-thousand-pipe Wurlitzer organ said to have cost $115,000, a whopping amount at that time.

St. Louisans have enjoyed watching baseball games and supporting teams for generations. This image shows the St. Louis Browns in 1888. *Library of Congress.*

Before the days of the St. Louis Cardinals baseball team, late nineteenth-century baseball fans gathered to cheer on the St. Louis Perfectos, shown in 1899. *Library of Congress.*

The Ambassador's interior details were a feast for the eyes, with silver leaf accents, marble and bronze. Stage shows as well as movies were a part of the theater's format until 1935, when it became exclusively a movie venue.

Attendance at the Ambassador was down by the early 1950s. The building was remodeled as a Cinerama theater, featuring a curved screen, more leg room and larger seats. By 1960, the theater was closed. It was reopened in the 1970s as a movie theater and concert venue but was closed again by 1976.

The Ambassador became a National Register property in the early 1980s, but that designation did not save it from the wrecking ball. It was razed in 1996. The theater's demolition was described by some as one of St. Louis's biggest architectural losses.

Grand Opera House

The Grand Opera House (also called DeBar's Grand Opera House and Grand Theater) was an oval-shaped building located on Market Street. It opened in May 1852 as the Varieties Theater and was one of the largest such entertainment venues. Theater management frequently placed advertisements for coming attractions in the *Missouri Daily Republic*.

The Grand Opera House had several names during its history. The popular gathering spot opened in 1852. *From* Commercial and Architectural St. Louis.

The theater was given a new façade in 1881, but it was destroyed by fire in 1884. It was rebuilt and reopened in the fall of 1885.

With a capacity of twenty-three hundred, the house attracted stage and theater stars of the time, including Edwin Booth, famed brother of John Wilkes Booth, President Abraham Lincoln's assassin. The theater was often filled, including the standing room–only section.

The building was known as Grand Theater when it was demolished in 1963. The site was reborn a few years later later as Busch Stadium, home of the St. Louis Cardinals baseball team.

Hagen Theater

The Hagen Theater, located at Tenth and Pine Streets, must have been a spectacular sight when it opened. The five-story structure was built with brick and featured stone ornamentation. A large, multifaced clock towered over the building's exterior corner at Tenth and Pine. Two entrances allowed patrons to enter from either street. The lobby floor was covered with mosaics. The lobby also included a glass dome and two marble staircases leading to the balcony.

Havlin Theater

The Havlin Theater, located at the southwest corner of Sixth and Walnut Streets, first opened its doors in 1880. It featured private upholstered boxes and interior wall frescos. In 1891, Havlin Theater was described as "plush," and it was a popular and convenient place for theatergoers. It could seat more than two thousand people.

The theater was heavily damaged during the tornado that hit St. Louis in May 1896.

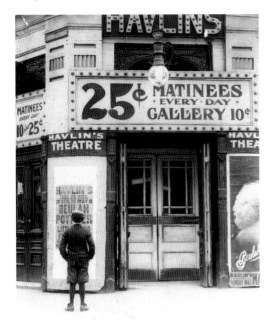

The Havlin Theater was popular with theatergoers. A major tornado hit St. Louis in the spring of 1896 and damaged the theater, as well as numerous residences and commercial buildings. *Library of Congress.*

LIEDERKRANZ

St. Louis's Liederkranz was a German singing organization dating to 1870. It was located in a rented downtown hall at Chouteau Avenue and Thirteenth Street until 1907. The site was an exclusive venue and popular social gathering spot for wealthy German Americans living in St. Louis.

Liederkranz had its own building constructed in 1907, with facilities and recreational opportunities much like those found at other private clubs. Today, the Liederkranz is a choral society dedicated to the preservation of traditional German music in St. Louis. Both buildings have been demolished.

LOUISIANA PURCHASE EXPOSITION, 1904 WORLD'S FAIR

It was designed to be and described as a world's fair like no other. In 1904, the world literally came to St. Louis. More than twenty million people passed through the fair's entrance gates during its seven-month existence. Forest Park, St. Louis's sprawling public green space established several decades earlier, was selected as the site for the planned exhibition. The park's more than twelve hundred acres hosted many temporary buildings constructed specifically for the fair. The mile-long Pike featured lavishly decorated palaces, more than one thousand artistic statues, floral gardens and lakes. In addition, that same year, St. Louis hosted the Summer Olympics, beating out rival city Chicago. It was only the third such modern-day Olympic competition.

Some of the most popular attractions included Festival Hall, the Cascades, Colonnade of States, the Grand Basin, the Great Floral Clock, Chinese Pavilion, the Louisiana Purchase Monument and the Observation Wheel. The Observation Wheel stood 264 feet high and had thirty-six cars,

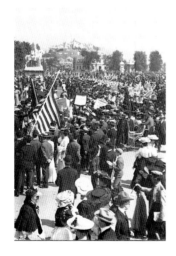

St. Louis Day was one of many "specially designated days" featured during the months-long tenure of the 1904 World's Fair. *Library of Congress.*

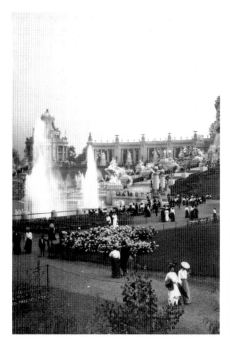 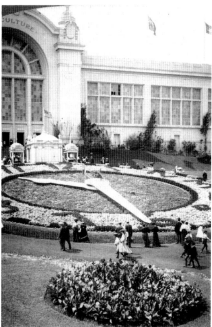

Left: The world—more than twenty million people—came to St. Louis for the Louisiana Purchase Exposition, the 1904 World's Fair. *Library of Congress*.

Right: Several foods were popularized during the 1904 World's Fair, but only one was introduced during the fair: puffed rice. A giant floral clock was also a popular attraction. *Library of Congress*.

each of which held sixty passengers. A ride on the wheel cost an expensive fifty cents but provided an outstanding panoramic view of the entire fair.

The Inside Inn was the only hotel constructed inside the fairgrounds. It featured 2,257 rooms and a staff of two thousand. Rooms cost $1.50 per day, $3.00 with meals included. After the fair, the hotel's operator, Ellsworth Milton Statler, started an international hotel chain.

At night, the fairgrounds became an illuminated fairy land as hundreds of newly developed electric lights glowed for all to see. But as intricate and detailed as the fair's structures and ornamentation were, they were not built to last.

A building substance called staff was used to construct the temporary buildings, decorative features and many statues. When the fair closed, most everything was torn down and destroyed. A stroll through St. Louis's Forest Park, the location of the fair, provides few hints that the ornate structures ever

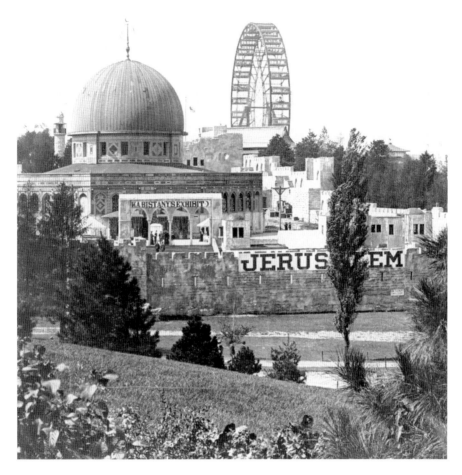

St. Louis hit the world stage in 1904. It was a time to showcase the city to the millions of people attending the Louisiana Purchase Exposition. *Library of Congress*.

existed. Part of the building that today houses the Saint Louis Art Museum was used during the fair and was designed to be permanent. The Saint Louis Zoo's walk-through Flight Cage was constructed for a Smithsonian Institution exhibit at the fair and was supposed to be temporary, but its popularity and uniqueness led to its survival.

A look at photographic images from the fair shows the intricate details and flourishes artisans were able to create with the cheap building material. And in the end, it was all torn down and became gigantic piles of rubble.

The following remembrances of the world's fair are attributed to Clark McAdams in 1909:

Lost St. Louis

Don't you remember the old Fair Grounds
 The arch above the gate,
The stalls and the merry-go-rounds,
 And the windmills tall and straight
That spun around at a merry rate
 When the autumn wind would blow
And the season was grown soft and late
 In the long, long time ago?

The prize ring and the circling seats,
 The sulky's flashing wheels,
And the gaited saddler's matchless feats
 With the sunlight on his heels?
The music, whinnies, moos and squeals,
 The judges stern and gray,
And the monkey cage with its mighty peals
 Of joy on children's day?

Don't you remember the display
 Of beauty and its wiles
In those old stalls, and that one day
 A Prince basked in its smiles?
The showmen in their high silk tiles,
 The barker and the clown,
And the planters following the styles
 In roadsters up and down?

The Thursdays when we all went out
 And gamboled on the green,
And no gallant was there without
 His girl in that gay scene?
The pumpkin, squash and the butterbean,
 The big prize winning cake,
The broad-backed hogs, and the silver sheen
 Upon the sylvan lake?

ENVOY.

Ah me! The Prince sits on his throne,
 The hallowed landmarks disappear,
And the beauty of a day is flown—
 Where are the fairs of yesteryear?

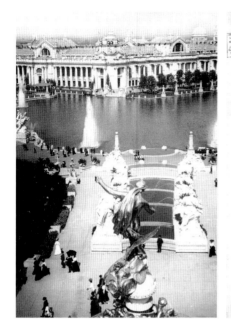

Left: The Rainbow Gardens were one of the many marvels on display at the 1904 World's Fair. Most structures and decorative arts were destroyed once the fair closed. *Library of Congress*.

Right: *Puck* was a popular early twentieth-century magazine with a sizable distribution. The closing of the 1904 World's Fair in St. Louis was featured on a cover. *Library of Congress*.

Olympic Theater

The first Olympic Theater opened in 1867 on South Broadway. It hosted minstrel shows and vaudeville-type acts. It closed in 1881 so its owner, Charles Spaulding, could raze it and build an even grander structure.

The new Olympic Theater building opened in the fall of 1882, featuring opulent, carved wooden interiors and a seating capacity of more than twenty-four hundred. Famed actor Edwin Booth appeared in productions here. It ceased operations in 1916, when audiences dwindled, drawn to newer theaters built near Sixth and Walnut Streets.

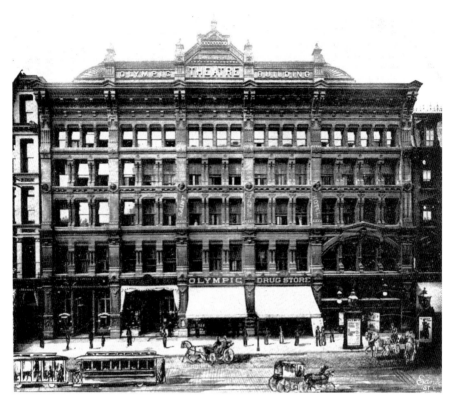

Two Olympic Theaters occupied property on South Broadway. The Olympic remained in business for almost fifty years. *Public domain.*

Pickwick Theatre and Illuminated Garden

The Pickwick Theatre and Illuminated Garden, located at Washington and Jefferson Avenues, was an early arrival to the part of St. Louis that decades later was nicknamed the "Bright White Way" due to its abundance of theaters and lights. The Pickwick opened in 1880 as a summer garden with a stage where concerts and theatrical performances were presented. During the summer, the garden supposedly was lit with one thousand gaslights.

The Pickwick Theater and Illuminated Garden lasted until 1883. It later became a lecture hall.

Princess Theater (also called Rialto Theater, Shubert Theater, Mid-City Theater)

The Princess Theater arrived in what became Grand Avenue's theater district in 1912. Located south of Olive Street, it featured vaudeville entertainment. The theater was renamed several times in its many decades in the area. It was known as the Rialto Theater, the Shubert Theater and Mid-City Theater before it closed in 1972. It was razed in 1978.

St. Louis Coliseum

The St. Louis Coliseum was located at the southwest corner of Jefferson and Washington Avenues. The St. Louis Exposition and Music Hall had been destroyed in 1906, and some local businessmen said the city needed a large new arena. The site chosen for the new St. Louis Coliseum had been home to a popular late nineteenth-century gathering spot called Uhrig's Cave. The coliseum was completed in 1908. It seated approximately fourteen thousand people and was built at a cost of $300,000.

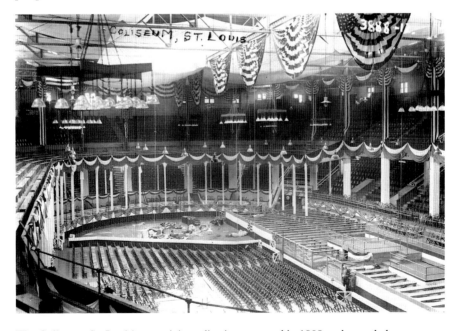

The Coliseum, St. Louis's new civic auditorium, opened in 1908 and seated about fourteen thousand people. It remained a popular gathering place for several decades. *Library of Congress.*

The coliseum drew crowds to events ranging from animal shows and religious gatherings to the 1916 Democratic Convention. The St. Louis Coliseum remained a popular exhibition site for several decades until newer structures like Kiel Auditorium were built farther west of the immediate downtown area. The building was razed in 1953.

St. Louis Exposition and Music Hall

When the St. Louis Exposition and Music Hall opened in 1884, it was touted as the best venue of its kind anywhere. It was built to house an annual fair. Located at Olive, St. Charles, Thirteenth and Fourteenth Streets, it had three large entrances, a seating capacity of approximately four thousand and a standing-room capacity of two thousand. The music hall's grand organ was said to be the largest and finest in town.

Several political conventions were held in the Exposition Hall, including the Democratic Convention in 1888 and again in 1904 and the Republican Convention in 1896. The Exposition and Music Hall was razed in 1906 to make room for the downtown public library, a building that continues in that capacity today.

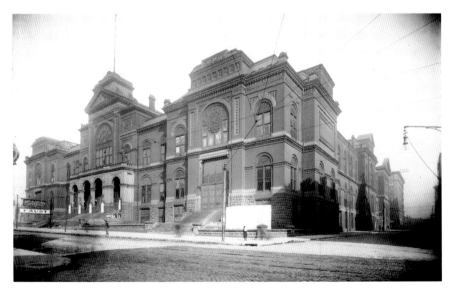

St. Louis Exposition and Music Hall was the city's early version of a civic auditorium. Both Democratic and Republican national conventions were held there. *Public domain.*

St. Louis Jockey Club at St. Louis Fairgrounds

The St. Louis Fairgrounds, located at North Grand Boulevard and Natural Bridge, became a popular gathering spot in 1855 when the first Fair of the St. Louis Agricultural and Mechanical Association was held there. The fair's popularity grew as it attracted larger crowds each year. By 1876, a small zoo and gardens had been added.

The members-only St. Louis Jockey Club was established in 1877. A group of businessmen bought property adjacent to the fairgrounds and several years later built a racetrack and a well-appointed clubhouse. The Jockey Club included a large grandstand and a one-mile racetrack, and it was the perfect place to raise and improve the performance of Thoroughbred racehorses. The track was said to be comparable to elite tracks found in Kentucky and New York. Large sums of money were known to exchange hands there.

In 1905, betting and wagering activities were outlawed in the state of Missouri. The St. Louis Jockey Club's clubhouse and other facilities were destroyed after that.

By that time, interest in the programs and activities once held at the fairgrounds had decreased as newer facilities were built elsewhere. The final Agricultural and Mechanical Association fair was held there in 1903.

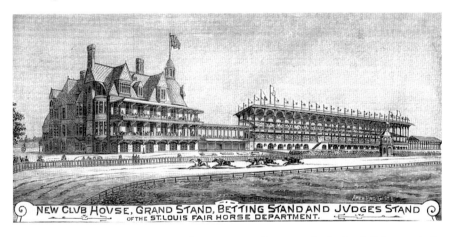

The St. Louis Jockey Club was opened on property adjacent to the St. Louis Fairgrounds. It was a popular destination for those who enjoyed horse racing. *Public domain.*

The City of St. Louis took control of the fairgrounds property in 1910 and continues to operate it as a public park, Fairground Park.

All fair-related buildings except the zoo's bear pit area and amphitheater were removed. The amphitheater was replaced with the city's first municipal swimming pool in 1912. Ball fields and tennis courts were added later.

St. Louis Turnverein

The turnverein, or turners' hall, was a tradition brought to St. Louis by German immigrants. Physical exercise was important to the German culture. Strong bodies and strong minds were desired. Once opened, these halls became places to participate in gymnastics and other forms of exercise, to find reading material and to socialize with others from *das vaterland*. In other words, turnvereins in St. Louis became social centers.

The first turnverein opened in 1850 in an area near the Mississippi River and the central business district. A strong concentration of Germans lived and worked in this area. By the 1860s, membership approached five hundred. As industry, and therefore jobs, began to spread outward from the downtown area after the Civil War, so, too, did the population. Several branch turnvereins opened in other neighborhoods, including the North St. Louis Turnverein and the South St. Louis Turnverein. By 1906, the St. Louis area had a total of twelve turnvereins.

Juvenile turners perform during St. Louis German Day at the 1904 World's Fair. The day was set aside to recognize the thousands of St. Louisans of German heritage. *Library of Congress.*

The outward migration also was detrimental to the turnvereins. As citizens of German heritage spread throughout the St. Louis area, there was no longer one tight-knit German community. In addition, by the early twentieth century, German immigrants were no longer flocking to St. Louis to start new lives.

Two other factors had a major impact on the popularity once enjoyed by turnvereins: the onset of World War I and an accompanying distrust and dislike of all things German; and the implementation in 1920 of Prohibition. St. Louis Germans brought with them a strong thirst for beer. Several dozen breweries existed in St. Louis prior to Prohibition, most run by German transplants who brought their brewing skills and recipes with them to America. Further anti-German sentiment was expressed during World War II.

One by one, the St. Louis turnvereins dissolved. By the second decade of the twenty-first century, only one group remained active.

Saint Louis Zoo Bear Pits

The Saint Louis Zoo for many decades featured bear "pits" for the display of various bear species. It was one of the first zoos in the world to replace barred cages with open habitats. These living spaces were created in the 1920s by construction workers from casts they made to resemble Mississippi River limestone formations. Here in the zoo's moated habitats, bear residents could roam, climb, eat and drink to the delight of zoo visitors.

The Saint Louis Zoo bear pits were a popular attraction for generations of visitors. The pits were man-made settings intended to resemble natural rock formations. *Postcard, public domain.*

In the early twenty-first century, the old bear pits were modified and became Bear Bluffs. A new polar bear habitat was built with a pool, tundra and other features to more closely emulate natural habitats. Improvements were made with the best interests of the animals in mind.

Saint Louis Zoo Chimp Arena

A feature attraction at the Saint Louis Zoo for many years was the chimpanzee show in the Chimp Arena. From 1942 to 2003, the zoo's trained chimpanzees entertained adults and children with antics and comical expressions.

Time passed. Today, zoo officials and animal experts try to understand animal residents' social needs and maintain them in ways complementary to their natural history. Gone are the costumes and silly antics. Animals at the Saint Louis Zoo can be observed in natural-like environments.

St. Louis Arena

The St. Louis Arena opened in September 1929 just south of Forest Park on Oakland Avenue. Through the years, it played host to an assortment of events and activities, including livestock shows; sporting events; professional soccer, basketball and St. Louis Blues hockey; circuses; and live concerts. The Arena featured a unique dome-shaped lamella roof supported by twenty cantilevered steel trusses, an engineering marvel at the time of its construction. The design required no upright support beams and therefore provided completely unobstructed views from all seats.

In the early 1980s, the Arena was owned by local company Ralston Purina and was called the Checkerdome. The Arena closed in 1994, when St. Louis's new downtown Kiel Center opened. A noncompete clause stated that the two venues could not operate at the same time.

City officials discussed ideas for reusing the old building, but nothing solid materialized. The decision was made to demolish The Old Barn. A February 1999 implosion destroyed the St. Louis Arena in thirty seconds. St. Louisans who spent many happy hours being entertained under

that domed roof mourned its passing. Today, business and residential complexes occupy the site.

Uhrig's Cave

Caves have long been used as natural cooling storage areas. Numerous caves once existed beneath the city of St. Louis. Most are now lost to history, due to collapses and fill-ins, but in the nineteenth century, before the days of automated refrigeration units, brewers of beer and related beverages found the cool confines of St. Louis's caves to be perfect storage areas.

In the years before Prohibition (1920–33), St. Louis was home to more than forty breweries. Brewery names like Cherokee, Bremen, Hyde Park, Griesedieck, Gast, Columbia, ABC, Lemp and Anheuser-Busch were common throughout St. Louis, and these companies utilized the city's underground caves for beer storage. Brewers reinforced and modified St. Louis's underground caves to meet their storage needs. Some had tunnels connecting them to aboveground buildings; others had natural springs running through them.

Joseph Uhrig's brewery dates to the middle of the nineteenth century. The natural limestone cave that came to be known as Uhrig's Cave was located between Locust Street and Washington Avenue, on the west side of Jefferson Avenue. When tables and chairs were set up in a cave chamber, the cave became one of the city's first beer gardens. It was one of the city's most popular watering holes and gathering spots—the perfect place to relax on a hot, humid St. Louis summer day and just a short ride from the Mississippi River levee. Customers brought picnics to Uhrig's Cave, and bands performed there.

The St. Louis Coliseum was built on the site of Uhrig's Cave in 1908. During Prohibition, illegal alcohol production was discovered in some of the cave's old underground storage areas. Parts of the cave were filled in to prevent further usage.

4
WHERE WE ATE, DRANK AND LODGED

Restaurants, Breweries and Accommodations

The city of St. Louis was in a growth mode following the Civil War. Commercial development at that time was moving away from the Mississippi River and centered on Fourth Street. Stores, offices, banks and premier hostelries were constructed in the area, including Planters' House Hotel, the Southern Hotel and Lindell Hotel.

St. Louis was home to more than fifty hotels in 1892, some more luxurious than others. At that time, a well-appointed room could be had for several dollars. Some, not all, followed the European plan, which did not include meals with a night's lodging.

Most any type of food could be found at dining establishments, from simple, hearty concoctions to lengthy, exotic menus featuring selections of meats, side dishes and desserts fit for a king. And beer flowed. Numerous breweries called St. Louis home, and they satisfactorily supplied the city's seemingly endless thirst for malt beverages.

AMERICAN HOTEL AND AMERICAN THEATER BUILDING

Built in 1907, the American Hotel and American Theater Building was located at Market and Seventh Streets. The building was of somewhat unusual construction. The hotel's two high-rise towers surrounded and dwarfed the much smaller theater building, but all three were joined as one building.

Many of the hotel's rooms featured a private bathroom, a novelty and luxury at that time. Harry S Truman once stayed there. The theater was known for many years as the place to see touring Broadway plays and productions. A lower-level restaurant called the Rathskeller was a popular place to dine in the 1930s.

Sudden plans to demolish the building were announced in 1953. A parking lot was built on the site. The area later was incorporated into the Gateway Mall.

Barnum's St. Louis Hotel

Barnum's Hotel was located at Second and Walnut Streets. At the time of its completion in the 1850s, it was considered St. Louis's first high-rise building and finest hostelry. The hotel was designed by architect George I. Barnett.

Former slave Dred Scott, who fought a lengthy battle for his and his wife's freedom, worked as a porter at Barnum's Hotel from 1857 until his death in September 1858.

Bartold's Grove

This three-story brick and stone structure was located at Manchester and Hanley Roads in an area once called Bartold Valley, part of today's Maplewood neighborhood. It was built about 1826 by an early settler to the area, German-born Henry Bartold.

The building sat about eight miles from downtown St. Louis and was for decades an ideal place to stop for a cold beverage on a hot day, have a picnic or stay for the night. It was said to be a place where both the famous and the infamous gathered. Bartold's Grove remained a popular stopping point until Prohibition began in 1920. At that time, it closed.

The building's age and unique exterior features secured it a place in 1933's federal Historic American Buildings Survey (HABS). At that time, few changes had been made to its original exterior. The building later reopened, but it was razed in the mid-twentieth century. The property where Bartold's Grove was located is now owned by Sunnen Corporation.

Bartold's Grove was a popular place to relax and enjoy a cold beverage. It closed during Prohibition. *Library of Congress*.

BEER GARDENS AND SALOONS

St. Louis loves its beer. Several dozen breweries were located in the city, and what better place to enjoy the foamy beverage than a beer garden. Beer gardens were plentiful in the late 1800s and early 1900s. A few were even located in the cool chambers of underground caves—an ideal choice for those hot and humid St. Louis days. Popular beer gardens included Ulrig's Cave (Jefferson and Washington Avenues) and Louis Weidner's Beer and Wine Garden (700 South Broadway). And if hanging out in a cave wasn't appealing, numerous aboveground bars and saloons dotted the city, always ready to satisfy the thirsts of parched St. Louisans.

DIPLOMAT MOTEL

The Diplomat Motel, with its simple mid-twentieth-century façade, sat at the corner of Kingshighway and Waterman Boulevard in the city's Central West End. Although by no means a richly adorned and appointed hostelry

The Diplomat Motel's clean lines and lack of adornment were symbolic of mid-twentieth-century architectural trends. *Postcard.*

like some of those found nearby, it was typical of the era's architecture that was becoming popular throughout the United States. The structure featured clean, straight lines, little adornment and only two stories. It was light, practical and functional, like so many houses and office buildings being constructed at that time. In addition, it offered road-weary travelers amenities of the day, like free surface parking, a relaxing swimming pool, television and radio.

The Diplomat Motel was built on the site of a hotel utilized during the 1904 World's Fair. Later, the Diplomat became a home for the elderly. The building was razed, and the property is now occupied by a religious organization.

Laclede Hotel

The Laclede Hotel was located at the southeast corner of Sixth and Chestnut Streets, at 518 Chestnut Street, for decades. Prior to its construction, the lot was home to St. Louis's jail. Through the ages, in every society, some members of its population behave badly, failing to follow societal rules of conduct. St. Louis was no exception. Residents constructed a small stone jail

in 1820. It was used until 1871, when a new jail was incorporated into the Four Courts Building.

The old jail was torn down, and in 1872, the site became the home of the Laclede Hotel. This hotel was considered by many to be St. Louis's most luxurious hostelry. A night's stay there in 1892 cost from two to three dollars. The hotel maintained that status for more than three decades and was a favorite of the Missouri Democratic Party. In 1915, the *St. Louis Globe-Democrat* stated, "Laclede linked the old and the new St. Louis; noted political center."

The Laclede Hotel continued to operate at the Chestnut Street site but fell into decline as the twentieth century progressed. It was demolished in 1961 to make way for the construction of Kiener Plaza.

Lindell Hotel

The Lindell Hotel was located at the northwest corner of Sixth Street and Washington Avenue. It was designed by Thomas Walsh of Ireland, architect of other notable St. Louis buildings, including St. Francis Xavier Church at Grand and Lindell and the Four Courts Building and Jail. Lindell Hotel took almost seven years to complete. Its grand opening attracted thousands who wanted see the lavish hotel for themselves.

Like many downtown hotels of the nineteenth century, it burned down, in 1867. The hotel was rebuilt and reopened in 1874. Afterward, it was proclaimed to be almost fireproof. The rebuilt version contained approximately 250 elegantly appointed apartment rooms and baths and steam heat. A night's stay in 1892 cost from $3.00 to $4.50.

As an example of early creative repurposing, businessman and philanthropist Henry Shaw, who donated land for Shaw's Garden (now called the Missouri Botanical Garden) and Tower Grove Park, salvaged pieces of the hotel's limestone exterior. The pieces were used to create the "ruins" that are still visible near Tower Grove Park's Sailboat Pond.

Marquette Hotel

The Marquette Hotel was built at 1734 Washington Avenue, on the southeast corner of Eighteenth Street and Washington Avenue, in 1906. It was designed by the architectural firm Barnett, Haynes & Barnett,

which also designed the luxurious Jefferson Hotel as the 1904 World's Fair's premier hostelry, the Catholic cathedral (New Cathedral) on Lindell Boulevard and numerous homes of wealthy St. Louisans. The Marquette's design included steel construction to help make it fireproof, an important consideration for hotels at that time. The ten-story brick building featured extensive terra-cotta and limestone ornamentation and bay windows.

Washington Avenue at that time was the center of shoe and clothing production and merchandising. The local businessmen who built the hotel felt certain that the hotel's central location would guarantee its success. On April 15, 1906, the *St. Louis Post-Dispatch* had this to say about the area and the new Marquette Hotel: "Not the least conspicuous of the buildings that are to grace the St. Louis wholesale district will be that constructed for hotel purposes at the southeast corner of Eighteenth Street and Washington Avenue. Here, in place of a one-story building, work has already begun on the new ten-story hotel with 400 rooms to cost $750,000. Two hundred rooms in this hotel will be set aside for visiting merchants, who will be charged a uniform rate of $1 per day each. For others, not in the mercantile trade, a slight increase will be made."

The hotel remained in business until 1977. By that time, Washington Avenue was no longer the business hub it had been. The Marquette Hotel was listed in the National Register of Historic Places in 1985. It was demolished in 1988 to make room for a parking lot.

NATIONAL (SCOTT'S) HOTEL

National (Scott's) Hotel was historically significant due to the nineteenth-century dignitaries who lodged there. It was razed rather than restored. *Library of Congress.*

National Hotel was located on the southwest corner of Third and Market Streets. The remains of an 1818 brick meetinghouse were combined with a nearby brick house, and it opened in 1832 as Scott's Hotel. The original hotel was destroyed and a new structure built in 1847. The new building was five stories tall and was known as the city's most luxurious hotel at the time. It was referred to as the New National or Scott's Hotel.

Notable guests who stayed under the hotel's roof included Daniel Webster and a young Abraham Lincoln and his family (prior to his presidency). The hotel went through several name

changes through the years, including United States Hotel, Germania House, Atlantic Hotel, St. Clair Hotel and Rice House.

The hotel was included in the federal Historic American Buildings Survey (HABS) but was subsequently demolished.

Planters' Hotel/The Planters' House

The history of Planters' Hotel in St. Louis actually involves three successive hostelries bearing that name. The first Planters' Hotel opened on Second Street in 1817. In 1837, ground was broken for the second Planters' House Hotel on Fourth Street. It opened in 1841 with several hundred guest rooms and was the city's first truly grand hotel. Famous guests and politicians stayed there when visiting St. Louis, including several U.S. presidents, author Charles Dickens and artist John James Audubon. A major fire broke out in the hotel in 1887. Several years passed before it was razed, and an elegant new hotel was designed.

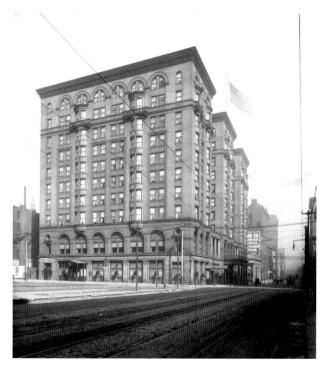

Planters' Hotel had a lengthy history in St. Louis, providing shelter for dignitaries and celebrities in three different buildings. *Library of Congress.*

The third incarnation of Planters' House Hotel included lavish interior details and an "E-shaped" exterior. It opened in 1893 and remained in operation until 1922, falling out of favor after World War I. The structure then was converted to an office building, first called Planters' Building and then the Cotton Belt Building. It was razed in 1976 to make way for the construction of Boatmen's Bank Plaza. The building later was called One Centerre Plaza and today is known as the Bank of America Tower/Plaza.

St. Nicholas Hotel (later the Victoria Building)

The original St. Nicholas Hotel was located on Fourth Street and was destroyed by fire in 1884. The second St. Nicholas Hotel, located at the northwest corner of Eighth and Locust Streets, was built in 1893 and opened in 1894. The building was designed by famed architect Louis Sullivan of the Chicago architectural firm Adler and Sullivan. Sullivan also designed the innovative Wainwright Building in the early 1890s.

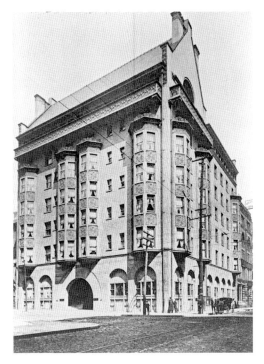

The St. Nicholas Hotel later became an office building called the Victoria Building. It was designated as architecturally significant but was demolished in the 1970s. *Library of Congress.*

The St. Nicholas Hotel's exterior included distinctive Sullivan-designed terra-cotta snowflake embellishments. The eight-story hotel was the hostelry of choice for notable individuals of the day.

The hotel was closed and sold in 1905. It was then remodeled by the architecture firm Eames & Young, and floors were added to the original building. It reopened as an office building with a new name, the Victoria Building.

Due in part to its distinctive ornamentation, the building was included in the Historic American Buildings Survey, which began in 1933 as a way to document the country's architectural heritage. However, the inclusion did not save the building.

The Victoria Building was demolished in the early 1970s, but not before historians saved some of the decorative trim and snowflake sections. The site existed as a parking lot for thirty-five years until it became part of a downtown plaza.

Southern Hotel

The Southern Hotel was located at the corner of Fourth and Walnut Streets, stretching between Fourth and Fifth Streets. It was built on the parcel occupied by the Old Southern Hotel until it burned in 1877. The hotel was rebuilt and reopened in 1881. White marble and extensive fresco work accented the building's interior, as well as a rotunda and wide promenade. The hotel took pride in declaring its new building to be "thoroughly fire proof." Nightly rates were from $3.00 to $4.50.

The Southern Hotel was owned by wealthy St. Louis businessman Robert G. Campbell, who enjoyed a close friendship with President U.S. Grant. Campbell's opulent home is now operated as the Campbell House Museum and features original family furnishings and belongings. It is the sole survivor of the nineteenth century's once-exclusive residential enclave known as Lucas Place.

The Southern Hotel closed in 1912 as new and larger hotels were built farther west.

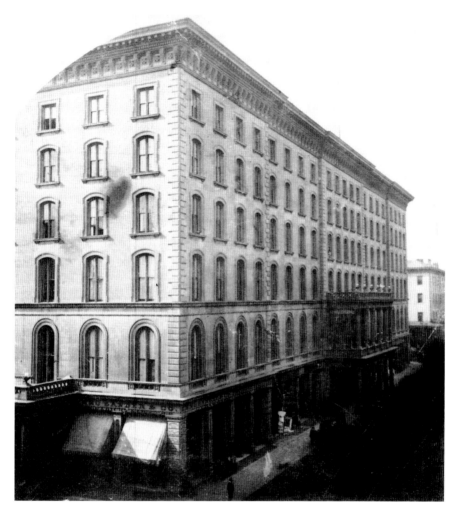

The Southern Hotel was owned by successful businessman Robert Campbell, whose residence is the only survivor of the exclusive Lucas Place enclave. *Library of Congress*.

Tony Faust's Oyster House and Restaurant

Tony Faust's Oyster House and Restaurant was located at the southwest corner of Broadway and Elm Street, next door to the popular Southern Hotel. It was a place to see and be seen in the late nineteenth and early twentieth centuries and was one of the nation's top restaurants. Both the famous and infamous enjoyed dining there. It featured an extensive fresh

seafood menu and served gourmet foods and condiments. An early wine list details scores of imported and domestic wine and alcoholic beverage choices. It also served Faust Beer, which was brewed nearby by the Anheuser Busch Brewing Association.

The restaurant began operations in 1871. In 1877, a fire destroyed the Southern Hotel and Tony Faust's Restaurant. Both were rebuilt. In 1888, Faust's Restaurant became the first St. Louis establishment to feature electric lights. As the upscale St. Louis population continued its flight westward, so, too, did Faust's customer base. The restaurant had fallen out of favor by 1911 and soon closed. The building was razed in 1933 during the Great Depression.

5
HOW WE TRAVELED

Transportation

The city of St. Louis was born, grew and thrived because of the Mississippi River. Before the days of railroads, streetcars, automobiles and trucks, there was the river and its neighbor rivers, the Missouri and Illinois. Commerce, trading and the shipping of goods relied on river transportation. By the mid-nineteenth century, St. Louis was the second-largest port in the United States. New York was the largest.

The site now known as St. Louis was selected due to its proximity to the river. As commercial opportunities increased, so, too, did the city's population. The two were directly correlated. Early river travel to and from St. Louis relied on the use of flatboats and oars or paddles. The 1815 arrival of the first steamer riverboat at the St. Louis levee forever changed the way people and products were transported on the river. The spread of railroads from East Coast cities westward in the 1850s soon replaced steamboats as the major mode of transportation.

The opening of Captain James B. Eads's bridge in 1874 provided even more transportation opportunities. People and cargo no longer had to be loaded and unloaded onto ferries to cross the Mississippi River. What once took hours to accomplish now took a matter of minutes.

With its location in the center of the United States and with the advantages of river and rail transportation, St. Louis was poised for commercial and civic success. By 1891, twenty-one railroad companies ran trains to and from St. Louis. The city became one of the top railroad freight centers. Soon, the newly opened Union Station became a central

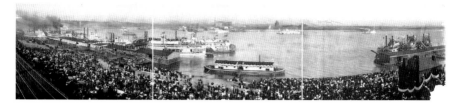

Before the days of Air Force One, visiting U.S. presidents arrived in St. Louis via riverboats. Large crowds gathered on the levee to greet dignitaries. *Library of Congress.*

railroad crossroads and transportation hub for people traveling to points throughout the nation.

The introduction of horse- and mule-pulled rail transit cars in the late 1850s and, later, the introduction of trolley cars and electric rail service greatly enhanced travel within St. Louis's city limits. Never ones to shy away from civic boasting, city leaders in the early 1890s claimed to have the best paved roads (some utilized granite) and the best rail service in the West. They called St. Louis the "Queen of the Mississippi Valley."

Author James Cox in 1894 published *Old and New St. Louis: A Concise History of the Metropolis of the West and Southwest, with a Review of Its Present Greatness and Immediate Prospects.* He said this about St. Louis's streets: "As the business streets were paved with granite, so did the standing of the city improve. History shows that, almost invariably, good roads and civilization have gone hand in hand; and the moral and commercial influence of good streets in St. Louis has been astounding."

The city was populated by so many horses and mules that watering troughs were constructed near some busy thoroughfares downtown and later in the Central West End. Electric car lines and a narrow-gauge railroad enabled turn-of-the-century St. Louisans to travel to different parts of the area, including St. Louis County.

As the popularity of the automobile increased in St. Louis, a planning commission was organized to evaluate the city's streets. A bond issue was passed in 1923 that enabled the widening of major thoroughfares like Market and Olive Streets and Gravois Road. The road surfaces of some major streets were improved as well.

As the twentieth century progressed, streetcars gave way to diesel-fueled buses as popular modes of public transportation. Cross-country bus service also was introduced.

Aviation began to play an important role in St. Louis in the early years of the twentieth century. The city's first air flight happened in the fall of

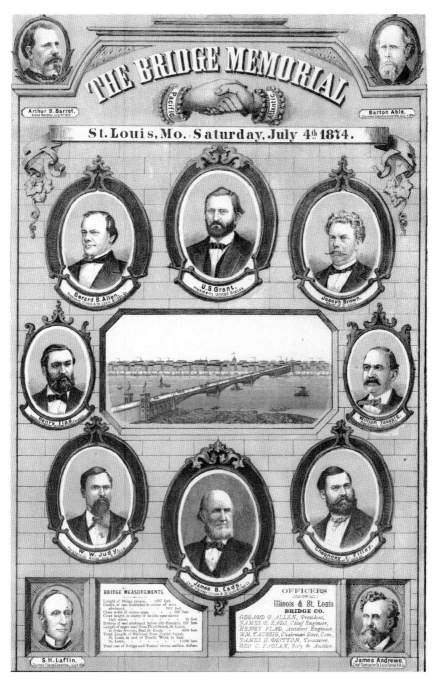

The opening of the Eads Bridge was cause for celebration. This program was distributed for opening-day ceremonies held on July 4, 1874. *Library of Congress*.

1909, when aviation pioneer Glenn Curtiss took to the air at Forest Park. In October 1910, Theodore Roosevelt became the first U.S. president to fly when he spent two minutes in the air over Kinloch Field (now St. Louis Lambert International Airport). A flying school was opened at Kinloch Field the following year.

It was during the International Air Races of 1923, held in St. Louis, that a pilot named Charles Lindbergh met some well-placed local businessmen. In 1927, these men sponsored Lindbergh's legendary nonstop flight between New York and Paris. He named his airplane the *Spirit of St. Louis* in appreciation of their support.

In the 1950s and '60s, St. Louisans were responsible for the design and construction of parts used on Gemini and Mercury spacecraft.

As the decades of the twentieth century rolled on, changes in St. Louis continued. Ideas and ways of life that once seemed essential faded away as new innovations and advances were introduced. Things that once were important were lost to progress.

Automobiles and Horseless Carriages

The popularity of horseless carriages and automobiles increased in St. Louis in the early twentieth century. For the wealthy St. Louisans who could afford them, Locust Street became the place to shop for vehicles. At one time, automobile dealerships lined both sides of part of Locust Street. Brands represented included Packard, Cadillac, Studebaker, Willys, Nash, Stutz, Moon, Dodge, Ford and Chrysler.

Then as now, showrooms displayed available automobile models. But in the days before assembly-line automobile production, each vehicle was made to order on-site. After the customer selected a vehicle, a build order was placed. Each automobile was then individually assembled in a garage located behind the dealership's showroom. The vehicles were picked up when completed.

Filling Stations, Dusters and Goggles

The new horseless carriages and automobiles were powered with motors that required petroleum fuel to operate. In 1905, what was described as the

Cross-country road races were a popular activity during the automobile industry's infancy. A lack of paved roadways made them a challenge to drivers. *Family photograph, author's collection.*

first drive-in "filling" station opened in St. Louis on South Theresa Avenue. Here, fuel could be purchased and dispensed into thirsty automobiles.

The opening of the first filling station turned out to be a monumental step in automotive history. Drivers now had the convenience of being able to drive their vehicles to the filling station to refuel and then be on their way.

Early automobile travel was a dusty and dirty endeavor, particularly before vehicles were equipped with roof-like covers. Few, if any, roadways had been improved or groomed, particularly in rural areas. Some early roads were macadamized with small crushed rock, but rutted paths were common, and clouds of dust were a frequent sight. And if it rained, the roadways often became rivers of mud.

Rugged roadway conditions meant numerous flat tires. The repairing or replacing of tire inner tubes was a necessary skill for drivers. Full-length canvas duster coats and protective goggles were necessary pieces of driving equipment for dealing with clouds of dust churned up by early automobiles. Both drivers and passengers donned this attire to protect their clothing and eyes from road grit.

The Knickerbocker Special, Union Station

Before the popularity and availability of airline travel, people frequently traveled cross-country via trains. The pace was leisurely, and the trip was quicker and less stressful than automobile travel. St. Louis's Union Station was a major hub of passenger rail activity for many decades. Tens of thousands of passengers passed through the station on their way to destinations throughout the United States.

A popular daily route existed in 1946 between St. Louis and New York City as part of the New York Central System. The train traveling between the two cities was called the Knickerbocker Special. According to the National Railway Publication Company's *Official Guide of the Railways*, passengers traveling from St. Louis's Union Station to New York City's Grand Central Terminal could expect the following:

Trip Duration: 22 hours, 35 minutes
17 intermediate stops
Average train speed: 51.2 miles per hour
Pullman and coach cars
Dining car service
Some air-conditioned sleeping cars

Passengers on the return Knickerbocker Special could expect a longer trip:

Trip Duration 24 hours, 10 minutes
26 intermediate stops
Average train speed; 47.8 miles per hour

Train travel diminished as the popularity of the automobile increased. The construction of interstate highways in the 1950s and '60s shortened the time needed for over-the-road automobile trips. In addition, the construction of roadside hostelries, service stations and restaurants made road travel easier.

McCutcheon Road Bridge

On the surface, the McCutcheon Road Bridge looked like most other vehicular highway bridges. It functioned nicely as it spanned western St.

The McCutcheon Road Bridge was one of only seven concrete rigid-frame bridges constructed in Missouri. After decades of use, it was replaced with a larger bridge. *Library of Congress.*

Louis's Interstate 40-64 and was much younger than the famed Eads Bridge over the Mississippi River. But the McCutcheon Road Bridge was somewhat unique. It was one of only seven concrete, rigid-frame bridges built in the state of Missouri.

The bridge was designed in the early 1940s and built in 1944 during World War II by the Missouri State Highway Department. At that time, the two-span overpass was deemed adequate for the amount of traffic it carried. But the population continued to spread west from downtown in the following decades. By the 1990s, the bridge was used by more than three thousand vehicles each day. When the Missouri Department of Transportation revised and replaced miles of Interstate 40-64, the McCutcheon Road Bridge was declared obsolete. A new overpass bridge was built to replace it in 2008.

The McCutcheon Road Bridge's construction was historically significant, enough so that it earned a place in the Historic American Engineering Record (HAER), which is similar to the Historic American Buildings Survey, the nation's first federal preservation effort. Nevertheless, the bridge was demolished and replaced.

Standard Oil Red Crown Filling Station

Standard Red Crown was a commercial name used by Standard Oil Company, a petroleum company founded by John D. Rockefeller in 1870. The company built a gasoline filling station at South Skinker Boulevard and Clayton and McCauseland Roads in 1932 and attached an enormous lighted advertising sign to the building's roof.

The sign was an electric marvel at that time, containing more than 5,500 light bulbs, almost three thousand feet of neon light tubing and literally miles of wiring. Its nighttime glow attracted the attention of passersby for several decades, but the amount of electricity it used made it expensive to maintain.

A service station still stands at this site. The Red Crown sign was removed in September 1959. In recent decades, a large Amoco sign has adorned the building's roof. Amoco was the name several affiliated companies chose after merging. Time passed, and Amoco became BP. A few stations, including this one, chose to maintain their Amoco signage. The sign is said to be one of the country's largest such signs.

Steamboats and Riverboats

The Mississippi River was an active transportation and trade route for thousands of years before Pierre Laclede settled a village later known as St. Louis. After hand-hewn canoes and flatboats traversed the water, along came a major innovation—riverboats with paddle wheels and steam engines. However, St. Louis's steamboat era had its share of problems. Steamboats were dangerous. Their boilers were prone to explode, injuring and killing passengers as well as crew members.

In 1871, the value of steamboats registered at St. Louis exceeded $5.4 million. They had become important as vehicles of trade as well as transportation.

One of the most impressive early luxury passenger steamers to dock at the St. Louis levee was the *Grand Republic*. It no doubt was a phenomenon in its day, with a passenger capacity of 3,500.

Vessels like *Grand Republic*, *City of Providence*, *Mark Twain*, *Spread Eagle* and others were the preferred mode of long-distance transportation until the Eads Bridge was completed in 1874. After the bridge opened, train service arrived and departed directly from St. Louis without having to ferry trains

and passengers across the Mississippi River to and from Illinois train connections. It did not take long for rail transportation to surpass river transportation in popularity.

Trolleys and Streetcars

Street railway operations became a reality in the years leading up to the Civil War. The first streetcar route opened in July 1859, running on Olive Street between Fourth and Tenth Streets. Horse- and mule-drawn rail cars and omnibuses became a more convenient mode of transportation for some than wagons and carriages.

Several companies operated St. Louis's streetcar lines. Improvements were introduced after the war, including mechanical and steam operations, as well as electricity and the installation of electric rails. Service availability increased in the city with the addition of more lines. A numbering system was developed for the various transportation "lines" run by the streetcars. The numbering system was then paired with corresponding community name assignments. For example, a rider wanting to visit Forest Park would look for "51 Forest Park" posted near the roofline of passing streetcars. Once the number was spotted, that was the streetcar the rider boarded. Also during this time, St. Louis became a top producer of streetcars, thanks to businesses like St. Louis Car Company.

Trolleys and streetcars remained popular modes of transportation until the 1920s, when motor-driven buses were introduced. Many bus lines followed the same routes utilized by streetcars. The 1950s and '60s construction of Interstate 70 through many St. Louis neighborhoods may also have contributed to the demise of streetcars. Streetcar service ended in St. Louis in 1966.

6

WHERE WE SHOPPED

Department Stores, Shops and Grocery Stores

The village of St. Louis quickly grew into a city as the nineteenth century progressed. In St. Louis's early days, the barter-and-trade system was most often used for the exchange of essential goods and services. The city's proximity to the Mississippi, Missouri and Illinois Rivers made it an ideal trade and commercial center. And as the city grew, so, too, did the number of shops, stores and groceries.

Downtown was the city's commercial hub throughout the nineteenth century and until the mid-twentieth century. Steamboats and trains delivered a varied assortment of goods to the city each day. A few small dry goods stores grew into major independent, locally owned department stores. In the early years of the twentieth century, dozens of dry goods stores called St. Louis home. Some of these stores grew and remained active in St. Louis commerce until recent years.

A. Moll Grocer Company

Grocery stores today are much different than they were a century ago. Instead of long aisles of seemingly endless choices in an enormous, well-lit, warehouse-like structure, shoppers faced wooden shelves usually stocked from floor to ceiling with small selections of a few products. Large rolling carts with room for piles of items, as well as for several small children, did not exist.

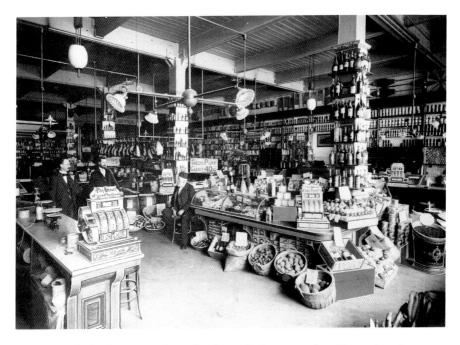

Groceries in St. Louis were much smaller than today's supermarkets. Personal service was a specialty, and customers were allowed to maintain monthly purchase tabs. *Public domain.*

Groceries of the past offered personalized shopping experiences, in which the grocer knew each customer by name and his or her individual likes and dislikes. Grocers assisted customers by handing items to them from the shelves. Frequent-shopper discounts, UPC scanners and chip readers did not exist. Not having cash in hand was not a problem if you were a "regular" or part of the household staff of a well-to-do patron. The day's expenditures would be added to the household tab and billed monthly.

A. Moll Grocer Company, located at 5659 Delmar Boulevard north of DeBaliviere Avenue, was one of St. Louis's most popular yesteryear grocers. Adolph Moll first ran a grocery on Franklin Avenue near downtown. His store and other retail establishments of the early twentieth century followed the expansion of St. Louis's streetcar system. Residential housing was being built farther west of downtown St. Louis in areas like University City. This seemed to be the perfect location for a grocer.

The grocer operated successfully in U. City for several decades in the twentieth century. The building that housed A. Moll Grocer Company was destroyed before the 1980s renaissance of University City.

B. Nugent & Bro. Dry Goods Establishment (Nugent Department Store)

The Nugent name was a familiar one in downtown St. Louis for many decades. The store that bore the Nugent name was long a fixture on the southeast corner of Washington Avenue and Broadway. Its original building was constructed in the 1850s.

As the twentieth century progressed, the firm expanded to a second building and constructed a four-story bridge across St. Charles Street to connect the two buildings. St. Louisans at that time had choices when it came to department stores. In addition to Nugent, there was Famous-Barr,

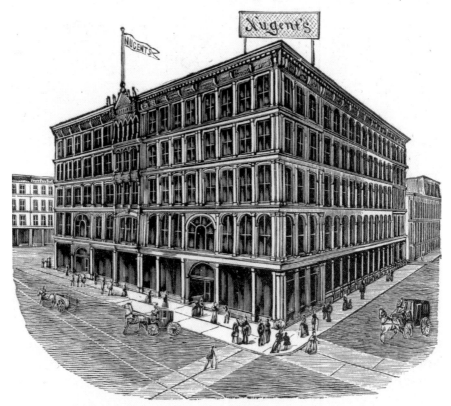

B. NUGENT & BRO. DRY GOODS ESTABLISHMENT.
Washington Avenue and Broadway.

B. Nugent & Bro. Dry Goods Establishment was later known as Nugent Department Store. It was one of many large department stores that once called St. Louis home. *Public domain.*

Scruggs, Vandervoort & Barney and Stix, Baer & Fuller. Nugent suffered economic setbacks during the Great Depression and closed in 1933. The Nugent annex building and bridge were demolished in 1942 to make way for a parking lot.

Famous Clothing Company

Famous Clothing Company was one of St. Louis's large downtown department stores. Located at the corner of Broadway and Morgan Street, it boasted more than 105,000 square feet of space. The company had previously been located on another site on Broadway.

Examining a Famous advertisement published in the May 21, 1905 edition of the *St. Louis Republic* is like taking a trip back in time. The ad spotlights everything from men's furnishings and boys' suits (five dollars to six dollars each) to women's shoes, hosiery, underwear and face powders (prices ranged from five cents to thirty-seven cents). Also featured in the ad were silk foulards, Japanese mattings, lace bedding and a double sanitary couch and pad (the era's version of a portable hideaway bed). If you needed it, Famous had it.

The store was divided into product categories, or "departments." Each department had its own manager/buyer of the products carried there, so in a sense it was like being able to shop at multiple stores, all under one roof. Locally, the phrase "department store" did not come into popular use until the early 1910s. Most people continued to refer to the large stores as dry goods stores, a name popularized in the nineteenth century.

Famous merged with William Barr Dry Goods Company in 1913, making it the city's largest department store. Famous-Barr operated as one of St. Louis's most successful businesses during most of the twentieth century. As the population moved away from the city and to St. Louis County, Famous-Barr followed, building successful satellite stores throughout the area.

Famous-Barr participated in a successful merchant marketing program in which trading stamps, called Eagle Stamps, were given to customers based on the amount of their purchases. Customers could then save these stamps and trade them in for merchandise when they accumulated specified amounts. Famous-Barr, as well as some local filling stations, utilized the Eagle Stamp program for much of the twentieth century.

The Grand-Leader Stix, Baer & Fuller Dry Goods Co.

Established in 1892, the Grand-Leader was another of St. Louis's large downtown department stores. In 1906, an eight-story building was designed by local architecture firm Mauran, Russell & Garden. The building fronted on Washington Avenue and covered the entire block bounded by Washington and Sixth, Seventh and Lucas Streets. It was the first St. Louis building specifically designed for mass-market retailing. An eleven-story section was added thirteen years later.

The store's name became Grand-Leader Stix, Baer & Fuller Dry Goods Company. It later became Stix, Baer & Fuller. A store directory for the downtown Stix, Baer & Fuller reads like a restaurant menu. It had a basement and mezzanine areas, plus six floors loaded with most anything a shopper could want or need, from clothing for all ages to health aids, wigs and furs. There were also several dine-in restaurants. The idea was to get customers to spend the day shopping in the store.

Stix, Baer & Fuller was purchased by Dillard's in the early 1980s. St. Louis thus lost a decades-long local retail connection. Dillard's tried to renew life in the downtown location but was unsuccessful.

Katz Drug Company at the Wellston Loop Building

Katz Drug Company advertised itself as "the world's leading cut-rate drug stores" and used the likeness of a cat as its company identification. It operated at street level in the now-demolished circa 1910 Wellston Loop Building at Easton (now Dr. Martin Luther King Jr. Drive) and Hodiamont Avenues from 1933 until 1946. The building was located beside the Wellston Streetcar Terminal. This was the end point for the streetcar line. Streetcars would "loop" around and head back to the city of St. Louis from there. The four-story brick Wellston Loop Building was ornate and featured extensive terra-cotta decoration.

The late artist Bob Cassilly was a visionary. He began collecting, repurposing and displaying what some might call architectural junk long before repurposing and recycling became popular. His collection of architectural "stuff" and castoffs is contained in a Washington Avenue

warehouse once occupied by the International Shoe Company. The warehouse today is called City Museum. It is a popular downtown attraction and draws visitors from throughout the world. Cassilly saved large, pristine pieces of the Wellston Loop Building's ornamentation when the structure was being destroyed in the early 2000s. Today, those pieces are displayed in a visual re-creation of parts of the building.

SCRUGGS, VANDERVOORT & BARNEY

Scruggs, Vandervoort & Barney began life in St. Louis as Scruggs, a dry goods company, in 1850. The store was located on North Fourth Street near Washington Avenue. Additional partners were added to the company, and the name was changed to Scruggs-Vandervoort-Barney Department Store.

The store relocated to the corner of Broadway and Locust Streets in 1888, occupying floors in the building constructed for the Mercantile Library.

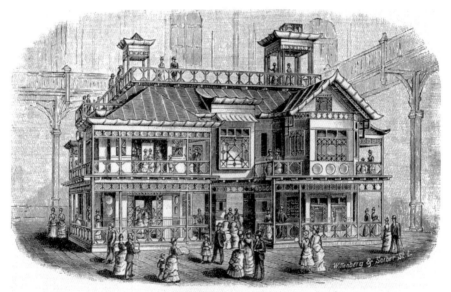

JAPANESE TEA HOUSE.
Broadway and Locust Street.
In Scruggs, Vandevoort & Barney's Dry Goods Establishment.

Scruggs, Vandervoort & Barney was a St. Louis department store catering to upscale shoppers. A Japanese teahouse was located within its building. The store closed in 1967. *Public domain.*

While at that location, the company had a Japanese teahouse constructed inside the building.

The company moved again in 1907, this time to the Syndicate Trust Building, located at Tenth and Olive Streets. It expanded into the nearby Century Building several years later. It also incorporated longtime St. Louis business Mermod Jaccard & King Jewelry Company.

Scruggs, Vandervoort & Barney Dry Goods Company marketed itself as a purveyor of fine merchandise and quality goods, not bargain merchandise. The company was the subject of a glowing article in the November 15, 1913 issue of *Drygoodsman and General Merchant* magazine. It stated the following about the company's attainment of high retailing ideals: "Making art a part of utility. Showing consideration while giving service. Combining the ideal with the practical. Retaining convenience while achieving magnitude. Satisfying the pride of craft while realizing profit from the business of merchandising. Displaying a spirit of modern progressiveness, yet retaining the sentimental and treasured tradition of four generations of purchasers."

The company had hundreds of employees, called itself the "fashion authority of the Midwest" and held fashion shows for both men and women. The company faced various challenges in the mid-twentieth century. The flagship store closed in 1967.

WILLIAM BARR DRY GOODS COMPANY

William Barr Dry Goods Company was founded in 1849. It was located near Fourth Street and Washington Avenue in the 1870s, near what at that time was St. Louis's central business district. The company relocated to Sixth and Olive Streets in 1880.

In 1913, the company merged with another local department store, Famous. The combined stores became Famous-Barr. The flagship store, located on the lower floors of the Railway Exchange Building since 1914, enjoyed many successful decades in the St. Louis area. Macy's purchased the company in 2005. The Famous-Barr name was replaced with the Macy's name in 2006.

7
WHERE WE HEALED

Hospitals

St. Louis grew quickly from a small fur-trading village to a river town, and from a thriving city to a large metropolis and transportation hub. The late nineteenth century saw a tremendous influx of people from all over the world. A lack of hygiene and little access to even primitive medical care meant the city harbored sickness and diseases and just smelled foul.

Infirmaries, hospitals and asylums, many with religious affiliations, were built to address the healthcare needs of St. Louisans. Camille N. Dry and Richard J. Compton published *Pictorial St. Louis, the Great Metropolis of the Mississippi Valley: A Topographical Survey Drawn in Perspective, A.D. 1875*. They had this to say about St. Louis hospitals:

> *In the matter of hospitals, we have eleven as noble institutions as ever graced any modern city—institutions whose hospitable walls multitudes are rescued from misery, and perhaps death, by the kind attentions of those to whom they were litter strangers, and on whom they had no claim but a common humanity. These buildings are all large, well ventilated, remarkable for strict cleanliness, and supplied with every facility for restoring the sick to perfect health. Some of these buildings are also highly ornamented, doing great credit to their founders and managers, and also to the city, by whom they are sustained. Some of them are self-sustaining, others are sustained entirely by charity. Both, however, deserve the greatest credit for the space they fill in our midst. We do not wish to make any invidious comparisons, but simple justice, which the public of St. Louis will not fail to appreciate,*

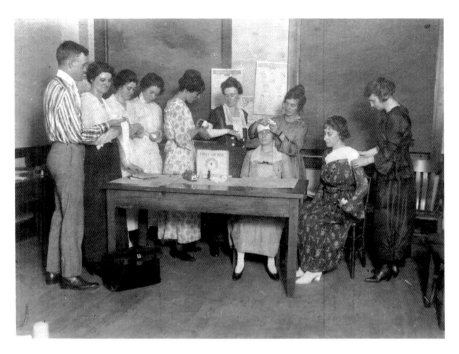

St. Louis has long been a leader in healthcare. Hands-on training was important for medical personnel helping with an influenza pandemic in 1919. *Library of Congress.*

compels us to state that the greater number of these establishments have been established by the friends of the Roman Catholic Church, whose members have, in all ages, been noted munificent charities.

Early hospitals and infirmaries included Quarantine Hospital, the Sisters' Hospital (Sisters of Charity), the City Dispensary, General Evangelical Lutheran Hospital and Asylum, Alexian Brothers Hospital, St. Luke's Hospital, Biddle Infant Asylum and Lying-in Hospital and St. Boniface Hospital. Other hospitals were organized, and some remain active healthcare providers today.

Barnes Hospital/Early Buildings

Robert Barnes arrived in St. Louis penniless, but he worked hard and became a wealthy man. He died a widower without children in 1892 and

earmarked $850,000 from his estate to build "a modern general hospital for sick and injured persons, without distinction of creed."

Barnes Hospital was built on a site near St. Louis's famed Forest Park. It opened in 1914. As the twentieth century progressed, the Barnes Hospital complex added a maternity hospital and an eye, ear, nose and throat hospital.

Barnes Hospital grew and today is a leader in medical innovations. In 1996, Barnes Hospital united with Jewish Hospital, another medical innovator, to become Barnes-Jewish Hospital. Today, the hospital's staff comprises some of the finest medical personnel in the United States. The hospital complex of today bears little resemblance to Barnes Hospital one hundred years ago.

City Hospital

The first City Hospital was built in 1846. Fire destroyed it ten years later, and it was rebuilt. In 1875, Camille N. Dry and Richard J. Compton described St. Louis's City Hospital as follows:

> *The oldest, as well as the most important of our public charities, is the City Hospital. This institution dates back over thirty years, and was built, is owned, and sustained by the city. In every respect it is, and always has been, a noble charity, a home for the suffering of all nations, where the sick and destitute stranger, be his nationality or religious creed what they may, finds a shelter from the storms of life, and kind and gentle hands to soothe his sick pillow. It is curious to notice in the returns of this establishment, made each year by the officer in charge, the various countries from which the patients come who are admitted here. Not only is every State in the American Union represented, but every country of Europe, South America, and even occasionally some portions of Asia. This goes to show what a point of concentration St. Louis is. It is a noble charity, to which the city can point with pride, as evincing the philanthropy of our people. Few public hospitals in the United States can compare with this. It is admirably arranged, in a high, airy, eligible position, and its cleanliness is the marvel and wonder of all who visit it. No pains are spared to make it attractive and agreeable, and much credit is due to the admirable management of the officers in charge, who sustain an exalted reputation for care and attention.*

> *The grounds, large and spacious, are neatly laid out, and present the appearance of a summer garden. The city, through the mayor and council, takes great pride in this important and valuable establishment, and the board of health especially watch over its arrangements, while the regular physician and his assistants, paid by the city, endeavor to make it all that the city wants—the very best of hospitals. The entire structure is built of the very best brick, and is finished in the most substantial manner, with ample supplies of water, bathing apparatus, and every convenience for the restoration of health and the promotion of comfort, that modern science and philanthropy have been enabled to devise. Attached is a drug store and other appurtenances, supplied by the city, and the whole is so arranged as to accommodate over six hundred patients.*

This structure lasted until the horrific tornado that hit St. Louis in 1896 destroyed it and so many other properties. A new City Hospital facility opened in 1907 as St. Louis's main public hospital. Additional structures were added to the central complex in the twentieth century.

City Hospital quickly filled as the influenza epidemic spread in St. Louis in October 1918. Private hospitals throughout the city did not accept influenza patients, so they came to City Hospital.

The complex was abandoned in the mid-1980s when the hospital relocated to a new facility. Five buildings were destroyed. The remaining structures were eventually renovated for residential living. Demolished buildings included the Malcolm Bliss Mental Health Center and the circa 1942 Tower Building.

Red Cross Motor Corps

In the fall of 1918, St. Louis's health commissioner, Dr. Max C. Starkloff, monitored with concern the nation's growing influenza epidemic as it spread westward from the East Coast. October arrived, and the number of reported cases of influenza in St. Louis spiked. Quarantines were implemented and public gatherings were cancelled. Hospitals overflowed with patients. Doctors and nurses were overworked. St. Louisans were dying.

And then the Red Cross, whose volunteer corps was already overworked, came up with a plan for securing and assigning volunteer nurses and aids throughout the city. With the approval of Dr. Starkloff, the Red Cross

dispatched personnel to provide home nursing services throughout St. Louis. Some Red Cross personnel provided food and clean linens to the sick in their homes. Others established a motor corps to transport medical personnel to and from quarantined homes and to provide ambulance service support when needed. An estimated forty nurses provided volunteer private care to more than three thousand patients, people who otherwise did not have access to needed medical services. In total, the Red Cross provided more than fourteen thousand such visits.

Social Evil Hospital
(later known as the Female Hospital)

Prostitution was legal in St. Louis for a brief time in the 1870s. Hygiene guidelines were developed and a hospital facility was built in conjunction with its legalization. Camille N. Dry and Richard J. Compton, in their 1875 book, had plenty to say about all aspects of life in St. Louis at that time. They described the city's Social Evil Hospital as follows:

> *This institution was for many years known as the Social Evil Hospital, and was erected in 1873, under the mayoralty of Hon. Joseph Brown, from a fund gathered under the provisions of the, now repealed, Social Evil Law. It is a handsome brick structure, costing over $100,000, and situated outside the city limits, at the intersection of the Manchester and Arsenal Roads. It was first used exclusively for the care and treatment of social outcasts, who, under the social evil law, were taxed for its support. Since the repeal of this law, which proved obnoxious to many of our citizens, it has been used as a female hospital exclusively, for the treatment of all the indigent and poor female sick of the city, from whatever disease or accident they may suffer.*

St. Louis Children's Hospital

St. Louis Children's Hospital began in 1879. It was the first such hospital to open west of the Mississippi River. The hospital was organized by a group of women in a downtown rented house. It had fifteen beds.

Today, St. Louis Children's Hospital provides care to more than 250,000 people each year. The hospital's reputation is such that people travel here from all over the world for its medical services. It is a pediatric learning hospital affiliated with Washington University's School of Medicine. St. Louis Children's Hospital specializes in the treatment of cerebral palsy, hearing impairment and asthma, as well as bone marrow, lung and liver transplants.

St. Luke's Hospital Birth Certificate

In 2016, St. Luke's Hospital celebrated 150 years of providing compassionate healthcare to the St. Louis area. Originally organized by the Episcopalian Church, many decades later it was joined in ministry by the Presbyterian (USA) churches. The hospital was initially located in a large house in the Soulard neighborhood.

The hospital's second location was at Washington Avenue and the northeast corner of Nineteenth Avenue, where it became known for its excellent nursing school. Frank V. Hammar was president of St. Luke's Hospital's board of directors in 1928. He said this about the hospital: "Conceived in the hearts of those who saw the need, Born under those influences that only the tender-hearted can give, Nurtured by those whose time is without price, And brought to fruition by those who desire to serve the Lord."

As the twentieth century progressed, St. Luke's built additional locations in different parts of the St. Louis area. It remains an active provider of healthcare services throughout St. Louis.

8
WHERE WE LEARNED

Schools and Education

As families with children moved to St. Louis, residents quickly realized that public schools of some sort were needed. Two were opened in 1838. Benton School (circa 1842) began as a place to educate young children. In 1853, St. Louis's first high school classes were held there as well. St. Louis's first high school for African Americans, Sumner High School, began in 1875.

Today, St. Louis is home to a variety of outstanding public and private education institutions with international reputations, and this was no accident. These were created and developed by St. Louisans who generations ago valued education and the training of young minds.

The kindergarten concept as it is known today in the United States began in St. Louis. St. Louisan Susan Blow traveled with her father to Germany. While there, she observed the early childhood education theories of educator Friedrich Froebel being applied to young students. Recognizing the importance of learning, play and structure for children, Blow opened the first publicly funded U.S. kindergarten in St. Louis's Carondelet neighborhood in 1873. Her ideas were soon recognized as essential to the growth and development of young minds and were incorporated throughout the country.

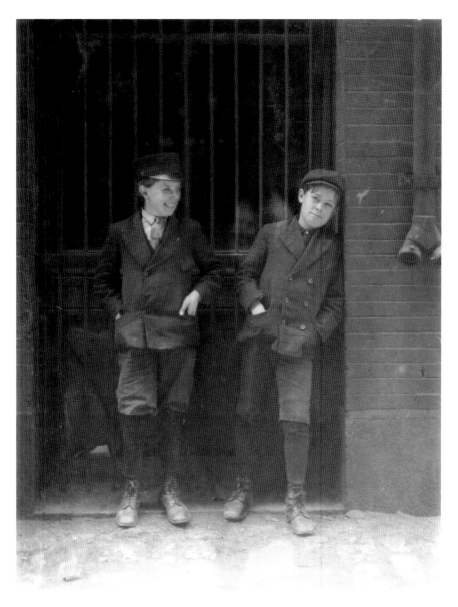

In the early twentieth century, some children dropped out of school to go to work. These young foundry workers were seen at Twelfth and Locust Streets. *Library of Congress*.

Academy of the Christian Brothers

This academy was located on the north side of Easton Avenue near Kingshighway and was run by Jesuit priests. The Academy of the Christian Brothers' classical course of study was designed to take seven years. The school accepted only day students. Those coming from distances to attend the school were responsible for securing their own lodging.

Beaumont Hospital Medical College

Beaumont Hospital Medical College was located at 2602 Pine Street at Jefferson Avenue. Its departments included histological, chemical, physiological, anatomical and bacteriological. A two-year program was available, but a third year of training was recommended.

St. Louis has a long history of association with medical training and healing-arts programs. At the end of the nineteenth century and in the early twentieth century, St. Louis was home to numerous medical colleges. Some colleges merged with other programs. Few from that time still exist. In addition to Beaumont Hospital Medical College, St. Louis was home to Hering Medical College, Homeopathic Medical College of Missouri, Barnes Medical College, St. Louis Hygienic College of Physicians and Surgeons, St. Louis Woman's Medical College and Marion-Sims College of Medicine.

Central High School

St. Louis's first high school building was also the first public high school west of the Mississippi River. It was built at Olive and Fifteenth Streets in 1855, one block from St. Louis's first exclusive residential enclave, Lucas Place. The school became known as Central High School and remained at this location until 1893. By that time, the area had fallen out of favor as a desirable place to live. Wealthy St. Louisans were moving farther west of downtown.

The school's second building was constructed at 1020 North Grand Avenue at Finey. That building was destroyed by a tornado in 1927.

Hayward's Short-Hand, Type-Writing and Commercial College

Fee-based commercial schools like Hayward's Short-Hand, Type-Writing and Commercial College offered educational opportunities for those who did not want a classic education. In later years, schools like Hayward's were referred to as business schools. Students were taught arithmetic, basic business math, company law, spelling and grammar, as well as typewriting and shorthand techniques.

Hayward's operated in the early years of the twentieth century. Advertisements for the school frequently appeared on the *St. Louis Republic*'s want-ad pages near posts about stenographers. The school was located at 702, 704 and 706 Olive Street. Enrollment was about four hundred students.

Jones Commercial College

St. Louis was home to an early commercial college, or what some would later refer to as a business college. Jones Commercial College was incorporated by the general assembly of the State of Missouri in January 1849. It operated at the southeast corner of Washington Avenue and Third Street.

The college offered classes in bookkeeping, commercial law, commercial calculations and penmanship, with an emphasis on bookkeeping for the growing steamboat industry. An 1854 catalogue says the college offered day and night classes. Tuition for night classes cost thirty-one dollars, one dollar more than day classes. The extra dollar was to pay for gas to illuminate the classrooms at night. The college experienced increased enrollment in its first five years of operation. Most of the college's students were from St. Louis and other parts of Missouri, but a few were from states as far away as New York and Massachusetts.

Outstanding penmanship was thought to be of the upmost importance at that time. Following is an excerpt from the college's course description of its penmanship classes:

> *To write a free, legible hand—such as should be used in the keeping of books, the making out of bills, or in the ordinary correspondence of a business man—is a desirable accomplishment in the education of young gentlemen for every profession; but, most especially, is it an object of first*

importance with those desirous of qualifying themselves for mercantile and business pursuits. No pains will be spared, on the part of the Professor in this department, to give a free and natural use of the arm, wrist and fingers, and to impart a cultivated taste for a plain, uniform and expeditious system of fine writing. Everything resembling a flourish positively prohibited with those designed for the counting-room.

For an additional charge, a student could obtain the privilege of having his handwriting reviewed and tweaked for life. By 1900, the college had moved to 309 North Broadway and was advertising in the *St. Louis Republic* want-ads section.

McDowell Medical College

McDowell Medical College was established in St. Louis in the 1840s by Dr. Joseph Nash McDowell. It was located at Cerre and Ninth Streets and was the first school of its kind in this part of the Midwest.

Dr. McDowell was a strong proponent of draining and filling in Chouteau's Pond for health reasons. He also was rumored to lead students on nighttime raids of local cemeteries, the goal being to secure recently buried bodies for medical research.

The school subsequently relocated to Eighth and Gratiot Streets. The building became Gratiot Street Prison during the Civil War, housing sometimes hundreds of prisoners. Dr. McDowell sought to reinstate the medical school after the war. He died several years later. The building remained empty and eventually was razed.

St. Louis Public Library

From the time it was organized in the 1860s, the city's public library was known as the Public School Library Society. A close alliance between the library and public schools was maintained. The library began as a subscription-based program run by the city's board of education.

By 1874, use of the public library was available to all St. Louisans, but library materials could only be used on-site. The library building was

located in the former Board of Education Building at Ninth and Locust Streets. In 1891, the library contained seventy thousand books. F.M. Crunden was serving as city librarian in 1892. In 1893, the decision was made to establish an independent library board and to allow patrons to check out materials at no cost.

A new Central Public Library building was designed by architect Cass Gilbert in 1912. It remains in use today and is located on the site of St. Louis's Exposition Building.

A branch library was built on Cass Avenue in 1909 and named the Crunden Branch Library in honor of the city librarian. The interior was ornate and richly detailed. Subsequent branch libraries were built throughout the city, and the Crunden Branch Library building was sold. It became the home of Pulaski Savings Association before it was razed.

St. Louis School and Museum of Fine Arts

Decades before the Saint Louis Art Museum moved into Cass Gilbert's 1904 World's Fair Palace of Fine Art Building in Forest Park, art in St. Louis was displayed at the St. Louis School and Museum of Fine Arts, located at Nineteenth and Lucas Streets near the prestigious Lucas Place residences. The School and Museum of Fine Arts had been organized in the 1870s as a department of nearby Washington University.

ART MUSEUM AND SCHOOL OF FINE ARTS. (Washington University.)
Lucas Place and Nineteenth Street.

Fine arts have been an important part of St. Louis for generations. The city's first art museum was dedicated in 1881 and was affiliated with Washington University. *Public domain.*

This elaborately appointed building was designed by Peabody & Sterns, a premier architecture firm located in Boston. The museum took two years to complete and was dedicated in 1881. It was home to the city's fine arts collection until 1906, when the collection was moved to Gilbert's building, the only permanent building left after the world's fair ended. The Lucas Street building was demolished in 1919.

Washington University

St. Louis's prestigious Washington University was not always located adjacent to Forest Park. And it did not have a medical school until 1891. The university began classes in 1856. Its early facilities were located on Washington Avenue and Seventeenth Street near prestigious Lucas Place. The medical school program began when Washington University and St. Louis Medical College merged.

The twentieth century brought plans for Washington University to move farther west near Forest Park. Multiple buildings were constructed, but the move was delayed when it was decided that the buildings would be used by the Louisiana Purchase Exposition, the 1904 World's Fair. Brookings Hall, the university's imposing central campus building, housed fair administration offices. Washington University moved to its new campus and buildings when the fair concluded. The university's original buildings no longer exist.

William B. Ittner Schools

William Ittner (1865–1936) was a St. Louis–born architect who was educated at Washington University and Cornell University. He returned to St. Louis to work for several local architecture firms, including Eames & Young, and Link Rosenheim and Ittner Architects. He designed several homes while working for the firms.

In 1897, he was elected to the St. Louis Board of Education to design school buildings. It was in this capacity that Ittner and his firm left their mark on St. Louis. Ittner was responsible for designing fifty St. Louis school buildings, as well as Midtown's Scottish Rite Cathedral and downtown's Missouri Athletic Club. He also designed several hundred

school buildings in other cities, including Nashville, Tennessee; Dallas, Texas; and Washington, D.C.

Many of Ittner's school designs featured unique E-shaped floor plans, architectural embellishment and brickwork, artistic touches like mosaics and the use of multiple windows. Most Ittner-designed school buildings in St. Louis still exist. Some serve in their original capacity as school facilities; others have been repurposed. Several are listed in the National Register of Historic Places. The attention to detail he gave the schools he designed is no longer found in public school building design.

9
WHERE WE PRAYED

Houses of Worship

Throughout its history, St. Louis has been a melting pot of people from varied nations, cultures, ethnicities and religious affiliations. As a result, an assortment of faiths and denominations was established and thrived here as the city grew. These affiliations included members of the Catholic, Jewish, Lutheran, Episcopal, Methodist, Presbyterian and Greek Orthodox faiths.

In St. Louis's early days, construction of a house of worship was a priority. Early settlers were predominantly French Catholics. A vacant lot was set aside for a Catholic church, the Church of St. Louis of France. That church today is known as the Basilica of Saint Louis, King of France—locally, it is known as the Old Cathedral. Protestant and other denominations came to the city as individuals from other faiths settled in the area.

Believers first met in homes or rented spaces, but as their religious communities grew, many built houses of worship, some more elaborate than others. Once established, local congregations often became the backbone of neighborhoods. Their structures provided places not only for worship but also for socialization, education, compassion, support and, in some cases, schooling.

Numerous religiously affiliated structures dot the city. Some are more than a century old. The interiors as well as exteriors of many attest to the skilled craftsmanship and artistry their creators brought with them from their former homelands. And some are beautiful in their simplicity and classic design.

Like other commercial and residential areas, houses of worship went through periods of growth and later decline. St. Louis's continued expansion, particularly westward, resulted in what were once elegant areas and neighborhoods falling out of favor. And as the people and businesses moved farther away from the downtown area, so, too, did the religious organizations. As some congregations moved west and away from the city, building new facilities, other religious groups moved into their former buildings.

A few congregations have maintained a strong presence in the St. Louis area for generations of believers. The journey for them has led to multiple facility changes. If their original structures were not repurposed or used by another religious organization, they often were destroyed in the name of civic progress.

Bethlehem Lutheran Church

According to its cornerstone, this church began life as Evangelical Lutheran Bethlehem Church. The brick and ornately embellished house of worship stood at the corner of Salisbury Street and North Florissant Road for more than a century. The building was designed by architect Louis Wessbecher in 1895 and featured intricate stained-glass windows. The congregation worshipped there until 1995, when weather-related events and fires caused damage. The congregation did not have the funds to renovate, so it moved worship services to a next-door building.

The beautiful building sat vacant. In 2014, part of the roof and then a wall collapsed. The remainder of the building was demolished.

Congregation Shaare Emeth

Congregation Shaare Emeth began in 1865 when an Orthodox congregation decided to raise money for the construction of a Reform synagogue. It would become St. Louis's first congregation organized as a Reform congregation. By 1869, the congregation, now called Shaare Emeth, occupied a temple at Seventeenth and Pine Streets. Its distinctive front featured two towers.

The congregation relocated to Lindell Boulevard and Vandeventer, with the new synagogue dedicated in 1897. Membership continued to move westward. The congregation relocated to Delmar Boulevard, with the new building dedication taking place in 1932. That building remains in use today by its current owner, the St. Louis Conservatory and School of the Arts (CASA).

And the westward migration continued. Land was purchased on Ladue Road in St. Louis County. Dedication of the new facilities took place in 1980.

First Congregational Church

First Congregational Church is the oldest Congregational church in St. Louis, dating back to 1852 when it was located at Tenth and Locust Streets. Following the westward residential move from downtown, the church was next located at Grand and Delmar Avenues. A final move to Wydown Boulevard brought the congregation to its current home. Its name was changed to First Trinity Congregational Church after a 2003 merger.

First Methodist Episcopal Church

As its name implies, First Methodist Episcopal Church was the Methodist Church's first congregation in the city of St. Louis. It began in 1821, when meetings were held at a house on Fourth Street near today's Old Courthouse. The following year, the congregation moved to a frame church at Fourth and Clark (formerly Myrtle) Streets. Its name was changed to Fourth Street Church in 1830 when it moved to a church building at Fourth and Washington.

A move to Eighth and Washington in 1854 was followed by an 1883 move to Eleventh and Locust Streets. The congregation moved away from the downtown area in 1884 to Glasgow Avenue and Dayton Street. It remained there until 1909.

St. Bridget of Erin Church

Beginning in the 1850s, St. Bridget of Erin Catholic Church was the center of St. Louis's Irish community. The brick church was located at Jefferson Avenue and Carr Street and was one of the city's oldest existing church structures. Religious services were held there until 2003.

The building was razed in 2016 after needed restoration work was deemed too extensive and too expensive.

Temple Israel

In the nineteenth century, an area of midtown St. Louis called Mill Creek Valley was filled with mansions, comfortable homes and numerous houses of worship. By the 1940s, the continued westward migration of the wealthy left much of the Mill Creek area in stages of urban decay. Preservation of architecturally significant buildings was not a priority in St. Louis at that time. By the 1950s, approximately 450 acres were slated for demolition and clearance.

Temple Israel has occupied several structures during its history. This building was located at Leffingwell and Pine. The congregation remains an active part of the St. Louis community. *Library of Congress.*

The Temple Israel building was vacated by that congregation in the early 1900s when another facility was constructed farther west of downtown. Located at Pine Street and Leffingwell Avenue, the building subsequently housed an African Methodist Episcopal church for many decades.

Although the building remained in excellent condition, it was one of several dozen houses of worship destroyed during the massive clearance of the Mill Creek area. More than one thousand homes, some still in good condition, met the same fate. Little decorative work and architectural detailing were salvaged prior to the buildings' destruction. Today's Interstate 40-64 cuts through part of yesteryear's Mill Creek area.

10
WHAT WE NEEDED
Services and Necessities

Nineteenth-century St. Louis was a city populated by thousands of people, as well as horses, mules and wagons. By the 1890s, St. Louis was the fourth-largest city in the United States. Life in a large city a century ago meant that certain products and services were necessary that are no longer essential today. These included water-sprinkling teams and wagons (the unpaved and cobblestone streets could become extremely dusty), ice and milk wagons (before the days of motorized delivery vehicles and in-home refrigerators), stables for the horses that pulled the various wagons and horseshoeing and saddlery shops (some offered horse snowshoes).

Another familiar sight at that time was the combination lumber/furniture-making/coffin firms and undertaking/livery operations. Lumber and furniture makers had the supplies and tools needed to produce coffins. Undertaking/livery operations had the horses to pull hearse wagons to burial sites.

Large, concrete, public watering troughs were located in busy parts of the city to provide water for the city's many working animals. Watering troughs were located at Broadway and Cass Avenue, near the police department, and throughout the city.

Only the homes of the wealthy were equipped with indoor plumbing. Most people made a trip to the outhouse or privy to take care of certain functions. High-density population areas saw the construction of multi-level privy vaults, or yard toilets. In 1910, Franklin Avenue, located just northwest of downtown, was one of those areas. Some privy vaults were stacked two

and three high and served as many as eighty people. Some aspects of St. Louis that have been lost with the passage of time are not missed!

Bathhouses

The nineteenth century was coming to a close. St. Louis was a growing city of employment opportunities, and immigrants from other countries flocked here to begin new lives. Soon, the city was the fourth-largest population center in the United States. As a result, streets and housing in downtown St. Louis were crowded.

Industrial waste in the growing city led to poor air quality. In the days before automobiles, work animals pulled wagons and carts through the streets, leaving their waste as they went. If an animal died, the carcass often was left for days until disposal. Only the homes of the very rich had running water, so bathing for the masses was only an occasional event. Outhouses frequently were shared by multiple families, and garbage and ashpits dotted yards. The lack of sanitation and personal hygiene made St. Louis an odiferous place.

Social reformers at the end of the nineteenth century sought to clean up large cities. This included the construction of public bathhouses, but St. Louis officials were slow to join the movement. St. Louis opened its first public bathhouse in 1907, several years after the world's fair. It featured separate entrances and facilities for men and women. Soap and towels could be brought from home or rented for a few cents at the bathhouse. Use of the bathing facilities was free.

The bathhouse became popular with city residents. Thousands of people utilized them. They were a place to bathe, but also a place for gathering to catch up on the latest neighborhood news. They were so popular that five additional bathhouses were built throughout the city. Locations included Tenth Street, Jefferson and Adams Streets, Lucas Avenue, the Soulard neighborhood and St. Louis Avenue in North St. Louis (the building remains).

In the twentieth century, newly constructed residences were equipped with running water and bath facilities. St. Louis's final bathhouse closed in 1965. Five of the bathhouses were destroyed, but the one on St. Louis Avenue remains, a reminder of a different era.

City Hall

A city hall building was constructed of brick at Eleventh, Chestnut and Market Streets. Some locals called the old building the "City Barn." By the late 1800s, the need existed for a new structure. More than a decade passed before the large, new city hall building on Market Street was completed in 1904. The old structure was torn down. The St. Louis Civil Courts Building, completed in 1929, continues to occupy the lot that once held the early city hall.

Clear Water

Clear water in St. Louis was only a dream until 1904. Civic leaders wanted the Louisiana Purchase Exposition, the 1904 World's Fair, to make a favorable statement about the city. St. Louis was about to hit the world stage, and every detail needed to be perfect in order to impress. This included the city's water supply, which had a distinct murky quality to it.

Author Mark Twain (Samuel Clemens) minced no words when it came to describing the water of the Mississippi River. During a visit to St. Louis in 1882, he said:

> *Every tumbler of it holds an acre of land in solution. I got this fact from the Bishop of the diocese. If you will let your glass stand half an hour you can separate the land from the water as easy as Genesis, and then you will find them both good—the one to eat, the other to drink. The land is very nourishing, the water is thoroughly wholesome. The one appeases hunger; the other, thirst. But the natives do not take them separately, but together as nature mixed them. When they find an inch of mud in the bottom of the glass, they stir it up and take the draught as they would gruel. It is difficult for a stranger to get used to this batter, but once used he will prefer it to water. This is really the case. It is good for steamboating and good to drink, but it is worthless for all other purposes except baptizing.*

In the months and weeks leading up to the fair's opening, purification methods were tested. A sedimentation process was tried that allowed particles in the water to filter and settle in holding areas, but tests showed a high level of bacteria remained in the water. Then a lime-and-iron solution was

added to the water, and the dream of crystal-clear water became a reality. In addition, almost all traces of bacteria disappeared. This resulted in a reduction in the number of cases of typhoid fever. The city's treated water looked better and was healthier to drink.

An elaborate water feature at the fair, the Cascades, was turned on—clean, clear water splashed and flowed. St. Louis successfully transformed murky water from the Mississippi River into sparkling, transparent rivulets.

Four Courts Building and Jail

The Four Courts Building and Jail (also called the Old Municipal Courts Building) was St. Louis's legal complex. It was bounded by Clark Avenue and Eleventh, Twelfth and Spruce Streets. The site previously was the location of wealthy businessman Henri Chouteau's large home and near what had been Chouteau's Pond.

The Four Courts Building's ornate construction and decorative façade gave little clue to the activities conducted inside. Designed by architect Thomas W. Walsh of Ireland, who designed the Lindell Hotel and other St. Louis structures, the sandstone building included dormers, mansard roofs, arches, hoods and a dome. The name "Four Courts" came from Dublin's Four Courts Building.

From 1820 until 1871, the St. Louis City Jail was located on Chestnut Street. It was relocated to the Four Courts Building and Jail. The new building also housed the city morgue and, behind that, the gallows. The city's police department was established in 1861. In 1872, police department headquarters moved from Chestnut Street to the new building. Police headquarters remained there until 1907, when it moved to a new building at 208 South Twelfth Street. The Four Courts Building was destroyed in 1907.

Harvey Nailing, Delivery Boy

Before the days of mandatory school attendance and child labor restrictions, it was commonplace in St. Louis and other large cities to see small children at work. Jobs ranged from delivering goods and hawking

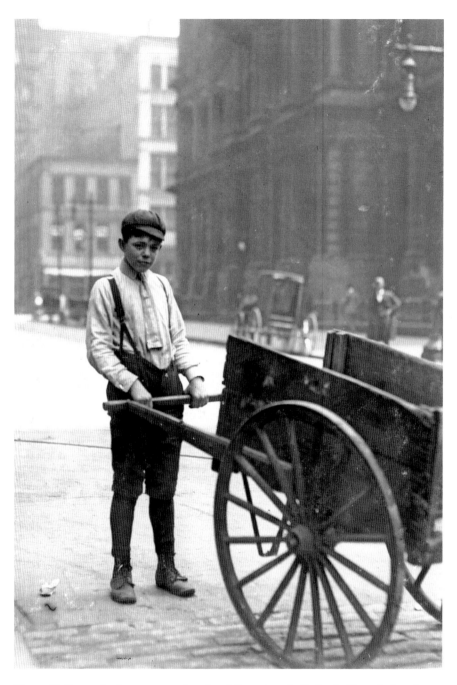

Harvey Nailing and others were employed as delivery boys in St. Louis. Formal education was not a priority for some families; earning money was. *Library of Congress*.

newspapers on street corners to laboring ten to twelve hours a day in factories. Large extended families needed every penny they could get, so children often were put to work at an early age.

Maxwell and Crouch Mule Company

St. Louis was a leader in U.S. mule and horse trading, attributable to the city's geographic location in the center of the country. Missouri-bred horses and mules were thought to be of a stronger stock than work animals from other parts of the country. In 1886, more than 42,000 horses and mules were shipped to the city via train and riverboat. By 1890, that figure had jumped to more than 82,000. This did not include the animals raised close enough to the city that they were herded here on foot. The demand for U.S. horses and mules was high in other countries, as well.

Maxwell and Crouch Mule Market was located near the Mississippi River. Today, the land once occupied by the company is part of Mullanphy Park. By the early twentieth century, the firm, run by brothers Howard and Warren Bailey, was operating from National Stock Yards, across the river in St. Clair County, Illinois.

National Bank of Commerce

The National Bank of Commerce began in 1857 as the Building and Savings Association. It was located at Second and Pine Streets. Several additional moves and name changes later, the organization secured the services of noted architect Isaac Taylor in 1901 to design an impressive new building at Broadway and Olive Street.

The structure was completed in 1902 and contained almost two hundred offices. By that time, the bank was one of the largest in the nation and was instrumental in providing cash and credit to smaller banks. This was in the days before the implementation of the Federal Reserve system.

Success continued, with the bank constructing additional buildings nearby, including a sixteen-story structure on North Broadway designed by the firm Mauran, Russell & Garden. The building would be the home of the affiliated New National Bank of Commerce. The two bank buildings

surrounded a much smaller building occupied by the *St. Louis Post-Dispatch*. An assortment of tenants occupied spaces in the newest building. By 1915, the St. Louis Federal Reserve Bank occupied space in the building, and the structure's name was changed to the Federal Commerce Trust Building. In 1936, the federal government purchased the building, which then housed Veterans Administration offices.

During the twentieth century, the bank moved from the Isaac Taylor–designed building. The structure then was occupied by the St. Louis Chamber of Commerce and was subsequently called the Chamber of Commerce Building. It and the Veterans Administration building were razed in 1977. Their sites became a parking lot. A large office building has occupied the sites for several decades.

Pevely Dairy Company

Family-run Pevely Dairy Company operated in St. Louis for more than one hundred years. It was one of the oldest such locally run businesses still in existence. In 1989, the company and its facilities were purchased by Prairie Farms Dairy.

Pevely Dairy Company's eight-acre, three-building complex was located at South Grand and Chouteau Avenues and included structures dating to 1915. Prairie Farms Dairy ceased all operations at this site in 2008. Most St. Louisans remember Pevely's highly visible brick smokestack with "Pevely" spelled out in white diagonal letters.

The campus of nearby St. Louis University has continued to grow in recent years. Several years ago, the school purchased additional land for redevelopment and facilities expansion, including the land parcel occupied by the Pevely Dairy. Although the Pevely Dairy Company's complex was placed in the National Register of Historic Places in 2009, approval was granted for the demolition of the historic buildings and smokestack. Thus ended a chapter in St. Louis history that included horse-drawn—and zebra-drawn—milk wagons.

Photography Studios

Photography—the ability to capture images on glass plates and, later, film—was extremely popular in nineteenth- and early twentieth-century St. Louis. William Hyde and Howard L. Conard, editors of 1899's *Encyclopedia of the History of St. Louis, A Compendium of History and Biography for Ready Reference*, had this to say about photography in the city: "St. Louis has good reason for being proud of its photographers, for their genius, taste and skill are recognized in places far remote from the scene of their labors, and there is no city in the United States, nor even in the world where better pictures are to be found than in the galleries of St. Louis artists."

At that time, St. Louis was home to hundreds of photography studios, which often were nothing more than a storefront with a small studio setting and backdrops in an upstairs space. St. Louisans were willing to spend hard-earned money in order to forever capture images of loved ones. One of the more popular photography studios belonged to sisters Emme and Mayme Gerhard and was located on Olive. Others included pioneer photographer Thomas M. Easterly, J.C. Strauss, F.W. Guerin, Frederick R. Parsons and Cramer Gross & Company.

St. Louis Globe-Democrat

In 1875, the *Missouri Democrat* merged with another local newspaper, the *Globe*, to form the *St. Louis Globe-Democrat*. The *Globe-Democrat* was known as an industry innovator and had the reputation of being one of the country's finest newspapers. It merged again in 1919, with the *St. Louis Republic*. Following the merger, an editorial policy statement was released: "The Globe-Democrat is an independent newspaper, printing the news impartially, supporting what it believes to be right and opposing what it believes to be wrong, without regard to party politics."

The *St. Louis Globe-Democrat* once referred to its building facility as "the Temple of Truth." It competed for many decades with the *St. Louis Post Dispatch* before ceasing operations in the mid-1980s.

St. Louis Mayor's Letter of Introduction

In the days before mass communications, life moved at a slower pace. Certain niceties and rules of etiquette were followed in various areas of life, including travel and deportment. It was not unusual for a city leader to write a letter of introduction for local travelers to carry with them when they traveled outside the United States. Such was the case for St. Louisans Sidney Boedeker and J.P. Maginity. In July 1922, St. Louis mayor Henry W. Kiel wrote a letter of introduction for the two young men to carry with them as they traveled in South America, assuring officials who might question the nature of their trip that these were upstanding St. Louisans and therefore should be welcomed. The letter stated: "To Whom It May Concern:—This is to certify that Mr. Sidney Boedeker 3523 University Street, and Mr. J.P. Maginity, 3838 Greer Avenue, native citizens of this city, are contemplating a trip to South American countries. These gentlemen are highly respected citizens of the City of St. Louis, having spent their entire life here, and any courtesies that you may be able to show either of them will be appreciated by me."

This type of communication is difficult to fathom is today's world of instant messaging, heightened security measures and legal documentation proving one's country of origin.

St. Louis Post-Dispatch Building

The *St. Louis Post-Dispatch* was established in 1878 when a young immigrant named Joseph Pulitzer, once a reporter for the German-language *Westliche Post*, merged two existing newspapers, the *St. Louis Dispatch* and the *St. Louis Post*. Upon combining the newspapers, Pulitzer said the following:

> *The Post and Dispatch will serve no party but the people; will be no organ of "Republicanism," but the organ of truth; will follow no caucuses but its own convictions; will not support the "Administration," but criticize it; will oppose all frauds and shams, wherever and whatever they are; will advocate principles and ideas rather than prejudices and partisanship. These ideas and principles are precisely the same as those upon which our government was originally founded, and to which we owe our country's marvelous growth and development.*

Pulitzer's leadership helped the *St. Louis Post-Dispatch* become the top St. Louis newspaper and one of the most respected publications in the United States. The *Post-Dispatch* published an afternoon daily newspaper and a Sunday edition.

The *Post-Dispatch* moved to various downtown buildings as it grew. A modest, six-story circa 1884 building located on North Broadway was home to the newspaper from 1902 until 1917. Although the building had previously housed several businesses, it came to be known as the Post-Dispatch Building. The newspaper's offices moved into a large, new building at Twelfth and Olive Streets in 1917, but the printing presses remained at the previous location for another year.

The building was included in the federal Historic Architectural Buildings Survey (HABS), but it and two others were razed in 1977 for the construction of an office building. The *Post-Dispatch* remains the city's only daily newspaper.

St. Louis Republic

The *St. Louis Republic*, located at the southeast corner of Third and Chouteau, was the city's oldest newspaper. It was founded in 1808 as the *Missouri Gazette*. In 1822, the named was changed to the *Missouri Republican*. The named changed to the *St. Louis Republic* in 1888.

St. Louis's population in 1854 was 97,000 people. The city had twenty-one newspapers and twelve magazines. Some of the newspapers were dailies, triweeklies and weeklies. By 1890, the city had eight newspapers, including three German-language publications.

Westliche Post

St. Louis became an extremely popular place for German immigrants to settle. In the late nineteenth century, it was estimated that one in three St. Louis residents was born in Germany. This population was large enough to support several German-language newspapers. The *Westliche Post* was established in 1857 as one of those German-language newspapers.

In the years after the Civil War, the *Westliche Post* became one of the finest and most influential German newspapers in the country. Joseph Pulitzer, who later founded the *St. Louis Post-Dispatch*, worked at the *Westliche Post* as a reporter. The newspaper moved to a building at Broadway and Market Street in 1874. It continued publication until 1939.

Wooden Barrels

Before the days of container shipments, cardboard boxes and metal storage bins, merchandise of all types was shipped in large wooden barrels. In the nineteenth century, steamboats arrived daily at the St. Louis levee. They often were loaded with wooden barrels containing foodstuffs, fabrics, essentials and decorative items.

The barrels were removed from moored steamboats by workers called stevedores. The barrels were then stacked at the levee for delivery to businesses throughout St. Louis. On a busy day, hundreds of barrels lined the levee.

Barrels were manufactured by companies called cooperages. St. Louis was home to several of these, including Eagle Cooperage Company. These cooperage companies no longer exist.

BIBLIOGRAPHY

Books

Bartholomew, Harland, City Plan Commission. *Problems of St. Louis*. St. Louis, MO: Nixon-Jones Print Co., 1917.
Bartley, Mary. *St. Louis Lost*. St. Louis, MO: Virginia Publishing Co., 1994.
Cox, James. *Old and New St. Louis: A Concise History of the Metropolis of the West and Southwest, with a Review of Its Present Greatness and Immediate Prospects*. St. Louis, MO: Continental Printing Company, 1894.
Dacus, J.A., PhD, and James W. Buel. *A Tour of St. Louis; or, The Inside Life of a Great City*. St. Louis, MO: Western Publishing Company, Jones & Griffin, 1875.
Darby, John Fletcher. *Personal Reflections of John F. Darby*. St. Louis, MO: G.I. Jones and Company, 1880.
Dry, Camille N. *Pictorial St. Louis, the Great Metropolis of the Mississippi Valley: A Topographical Survey Drawn in Perspective, A.D. 1875*. Designed and edited by Richard J. Compton. St. Louis, MO: Compton & Company, 1876.
Fremont, Jessie Benton. *Souvenirs of My Time*. Boston, MA: D. Lothrop & Company, 1887.
Gordon, Colin. *Mapping Decline: St. Louis and the Fate of the American City*. Philadelphia: University of Pennsylvania Press, 2008.
Gould's Blue Book for the City of St. Louis. St. Louis, MO: Gould Directory Company, 1913.
Hannon, Robert E. *St. Louis: Its Neighborhoods and Neighbors, Landmarks and Milestones*. St. Louis, MO: Buxton & Skinner Printing, 1986.

Bibliography

Harris, NiNi. *Downtown St. Louis.* St. Louis, MO: Reedy Press, 2015.

Heagney, Adele, and Jean Gosebrink. *Historic Photos of St. Louis.* Nashville, TN: Turner Publishing Company, 2007.

Heathcott, Joseph, and Angela Dietz. *Capturing the City.* St. Louis: Missouri History Museum Press, 2016.

Houck, Louis. *A History of Missouri from the Earliest Explorations and Settlements Until the Admission of the State into the Union.* Chicago, IL: R.R. Donnelley & Sons Company, 1908.

Hunter, Julius K. *Kingsbury Place, The First Two Hundred Years.* St. Louis, MO: C.V. Mosby Company, 1982.

Hyde, William, and Howard L. Conard, eds. *Encyclopedia of the History of St. Louis: A Compendium of History and Biography for Ready Reference.* Vols. 3 and 4. St. Louis, MO: Southern History Company, 1899.

Irving, Washington. *Astoria: Or, Enterprise Beyond the Rocky Mountains.* Accessed March 15, 2017. http://www.readprint.com/chapter-32263/Astoria-Washington-Irving.

Leonard, John W., ed. *The Book of St. Louisans: A Biographical Dictionary of Leading Living Men.* St. Louis, MO, 1906.

Leonard, J.W. *The Industries of Saint Louis.* St. Louis, MO: J.M. Elstner & Company, 1887.

Ling, Huping, PhD. *Chinese in St. Louis, 1857–2007.* Charleston, SC: Arcadia Publishing, 2007.

Orear, George Washington. *Commercial and Architectural St. Louis.* St. Louis, MO: Press of Buxton-Skinner, 1891.

Primm, James Neal. *Lion of the Valley: St. Louis, Missouri, 1764–1980.* St. Louis, MO: Pruett Publishing, 1981.

Rother, Hubert, and Charlotte Rother. *Lost Caves of St. Louis.* St. Louis, MO: Virginia Publishing Company, 1996.

Sharf, J. Thomas. *A History of St. Louis City and County, from the Earliest Periods to the Present Day, Including Biographical Sketches of Representative Men.* Vols. 2 and 3. Philadelphia, PA: L.H. Everts & Company, 1883.

Sharoff, Robert. *American City: St. Louis Architecture—Three Centuries of Classic Design.* Victoria, Australia: Images Publishing Group, 2010.

Sherer, S.L., ed. *Annual Exhibition of the Saint Louis Architectural Club.* St. Louis, MO: Shalcross Press, 1902.

Shewey, Arista C. *Pictorial St. Louis, Past and Present: A Sketch of St. Louis, Its History, Resources, Chronological Events, Tables of Interest.* St. Louis, MO, 1892.

Sonderman, Joe, and Mike Truax. *St. Louis: The 1904 World's Fair.* Charleston, SC: Arcadia Publishing, 2008.

Stevens, Walter B. *Centennial History of Missouri (The Center State): One Hundred Years in the Union, 1820–1921*. Vol. 5. St. Louis and Chicago: S.J. Clarke Publishing Company, 1921.

———. *St. Louis: The Fourth City 1764–1911*. Vol. 2. St. Louis and Chicago: S.J. Clarke Publishing Company, 1911.

Switzler, Col. W.F. *Switzler's Illustrated History of Missouri from 1541–1877*. St. Louis, MO: C.R. Barns, 1879.

Taft, William H. *Missouri Newspapers*. Columbia: University of Missouri Press, 1964.

Toft, Carolyn Hewes. *St. Louis: Landmarks and Historic Districts*. St. Louis, MO: Landmarks Association of St. Louis, 1988.

Newspapers and Other Materials

Cassella, William N., Jr. "City-County Separation: The Great Divorce of 1876." *Missouri Historical Society Bulletin* (January 1959).

The Drygoodsman and General Merchant. "The Scruggs, Vandervoort & Barney Dry Goods Company of St. Louis." November 15, 1913. Accessed March 25, 2017.

The 1854 Circular and Catalogue of Jones' Commercial College in St. Louis, MO. Accessed March 17, 2017. https://collegehistorygarden.blogspot.com/2012/04/jones-commercial-college-st-louis-mo.html.

Frank Leslie's Illustrated Newspaper. "Merchants Exchange Building during the 1876 Democratic Convention." July 15, 1876.

Hawes, George. Department of Mineralogy and Lithology at the National Museum. "Report on The Building Stones of the United States, and Statistics of the Quarry Industry for 1880: Missouri Building Stones & Geology." 1883. https://archive.org/stream/thescruggsvander00unse#page/n7/mode/2up.

"The Knickerbocker, New York Central System 1946." *The Official Guide of the Railways*. National Railway Publication Company. Accessed March 23, 2017. http://www.streamlinerschedules.com/concourse/track3/knickerbocker194603.html.

LaVack, Theodore. "Historic American Buildings Survey (HABS)." September 1936. https://www.loc.gov/search/?q=Historic+American+Buildings+Survey+St.+Louis.

Missouri Historical Society, *St. Louis Post-Dispatch*. "Where We Live: Central West End/DeBaliviere Place," 1994.

The National Humane Review. "Glanders and Public Horse Troughs." July 1913.

New York Times. "George D. Barnard Dies; St. Louis Merchant Who Founded a Skin and Cancer Hospital." June 1, 1915.

———. "The Pacific Railroad: First Train Through from St. Louis to Kansas City Railroad Excursion Party." October 2, 1865.

O'Neil, Tim. "A Look Back—Jack Daniels Distillery in St. Louis Was Target of Crime during Prohibition." *St. Louis Post-Dispatch.* December 6, 2009.

Photographic Images, 1904 Louisiana Purchase Exposition. Glass Negatives of Buildings by Various Unknown Photographers. Missouri History Museum Photograph and Prints Department.

Riverfront Times. "To Preserve and Protect: Esley Hamilton Has a Boundless Passion for St. Louis' Architectural Past." October 14, 2009.

Signs and Billboards Committee of the Civic League of Saint Louis. *Billboard Advertising in St. Louis.* St. Louis, MO: Civic League of Saint Louis, 1910.

St. Louis Post-Dispatch. "Here Are the $15,000,000.00 Sky-Scrapers and Great Buildings Going Up—St. Louis Biggest Boom." April 15, 1906.

St. Louis Star-Times. "Bridge and Annex at Old Nugent Department Store Coming Down." August 15, 1942.

Wayman, Norbury L. "History of St. Louis Neighborhoods: Downtown (C.B.D)." St. Louis Community Development Center, 1980.

———. "History of St. Louis Neighborhoods: Midtown." St. Louis Community Development Center, 1980.

Websites

Allen, Michael R. "The International Style in St. Louis Commercial Architecture." International Committee for the Documentation and Conservation of Buildings, Sites, and Neighborhoods of the Modern Movement. Accessed March 14, 2017. http://docomomo-us.org/news/international_style_st_louis_commercial_architecture.

Antique Advertising Expert. Accessed February 17, 2017. http://www.antiqueadvertisingexpert.com/project/american-brewing-co-abc-beer-serving-tray.

Ballparks Phanfare. "Ballparks, Arenas and Stadiums: St. Louis Arena—St. Louis, MO." Accessed February 13, 2017. http://www.ballparks.phanfare.com/2414471.

BridgeHunter.com. "McCutcheon Road Bridge." Accessed January 3, 2017. http://bridgehunter.com/mo/st-louis/bh36469.

Bibliography

A Brief History of St. Louis. Accessed February 13, 2017. https://www.stlouis-m.gov/visit-play/stlouis-history.cfm.

"Brief History of the Shapleigh Hardware Company." *The Winchester Keen Kutter Diamond Edge Chronicles* 1, nos. 3 and 4. The Hardware Companies Kollectors Klub. Accessed February 21, 2017. http://www.thckk.org/history/shapleigh-history.pdf.

Brown, Kathryn Sergeant. "Beavers and Boomtown: Remembering the St. Louis Fur Trade." *Missouri Conservationist Magazine* (February 1997). Accessed January 26, 2017. https://mdc.mo.gov/conmag/1997/02/beavers-and-boomtown-remembering-st-louis-fur-trade.

Built St. Louis. Accessed September 4, 2015. http://www.builtstlouis.net.

———. "Central Corridor: Historic Downtown." Accessed January 19, 2017. http://www.builtstlouis.net/opos/lutheran.html.

———. "St. Nicholas Hotel." Accessed January 19, 2017. http://www.builtstlouis.net/opos/victoriabuilding.html.

———. "Vanished Buildings: The Arena." Accessed multiple dates, January 2017. http://builtstlouis.net/arena01.html.

———. "Vanished Buildings: The Century Building." Accessed January 19, 2017. http://www.builtstlouis.net/century00.html.

Bygone St. Louis. "St. Louis Mutual Life Insurance Building, 1871." Accessed February 27, 2017. http://bygonestlouis.blogspot.com/2009/05/st-louis-mutual-life-insurance-building.html.

City of St. Louis, Missouri. "A History of St. Louis." Accessed April 11, 2016. https://www.stlouis-mo.gov/archive/history-physical-growth-stlouis.

———. "Alphabetical List of Current City Landmarks." Accessed February 25, 2017. https://www.stlouis-mo.gov/government/departments/planning/cultural-resources/city-landmarks.

Cultural Resources Office of the St. Louis Planning and Urban Design Agency. "St. Louis Flounder Houses, Flounder House Survey." Accessed January 30, 2017. https://www.stlouis-mo.gov/government/departments/planning/cultural-resources/flounder-house-survey.cfm.

Department Store Museum. "Stix, Baer & Fuller Store Directory." Accessed February 13, 2017. http://www.thedepartmentstoremuseum.org/2010/11/stix-baer-fuller-st-louis-missouri.html.

Downtown St. Louis Business. "Re-Saving Lindy Squared." Accessed January 19, 2017. http://downtownstlbiz.blogspot.com/2010/05/re-saving-lindy-squared.html.

Emporis.com. "Demolished Buildings." Accessed January–March 2017.

BIBLIOGRAPHY

Exploring St. Louis. "Cast Iron Storefronts." August 30, 2012. Accessed February 24, 2017. https://stlexplorer.wordpress.com/category/history/page/2.

Get Around St. Louis. "Downtown St. Louis Parking Facilities" (map). Accessed February 23, 2017. www.getaroundstl.com.

Immigrant Entrepreneurship. "The American Brewing Company, St. Louis, Missouri, ca. 1891." Accessed February 17, 2017. https://www.immigrantentrepreneurship.org/image.php?rec=1243.

Judge & Dolph Drug Co. advertisement. Accessed March 21, 2017. https://newspaperarchive.com/st-louis-world-fair-jan-01-1904-p-2.

Landmarks Association of St. Louis. Accessed February 13, 2017. www.landmarks-stl.org.

———. "William B. Ittner, FAIA (1864–1936)." Accessed January 24, 2017. http://www.landmarks-stl.org/architects/bio/william_b_ittner_faia_1864_1936.

Leagle.com. "Katz Drug Co. v. Katz." Accessed March 25, 2017. http://www.leagle.com/decision/195061789FSupp528_1493.xml/KATZ%20DRUG%20CO.%20v.%20KATZ.

Library of Congress. "Detail of east balustrade, view to the east—McCutcheon Street Bridge, Spanning Interstate 64, Saint Louis, Independent City, MO." Accessed January 3, 2017. https://www.loc.gov/resource/hhh.mo1883.photos/?sp=10.

"Mark Twain Quotation." Jean E. Meeh Gosebrink, Special Collections, St. Louis Public Library. Accessed March 7, 2017. http://www.ibiblio.org/archives-archivists/msg02700.html.

Missouri Department of Natural Resources. "St. Louis City National Register Listings." Accessed February 14, 2017. http://dnr.mo.gov/shpo/stlouiscity.htm.

Missouri Department of Transportation. "Mullanphy Park Site." Accessed February 21, 2017. http://www.modot.org/ehp/sites/MullanphyPark.htm.

Missouri History Museum. Cross-Collection Search—Photographs. Accessed February 25, 2017. http://collections.mohistory.org/resource/154417.html.

———. Genealogy and Local History Index. "Fifty Successful Years, 1858–1908." Accessed February 17, 2017. http://genealogy.mohistory.org/genealogy/browse/395.

Bibliography

———. "The 1904 World's Fair: Looking Back at Looking Forward. Overview of the Fair." Accessed March 3, 2016. http://mohistory.org/exhibits/Fair/WF/HTML/Overview.

———. "The 1904 World's Fair: Looking Back at Looking Forward. The Olympics." Accessed February 15, 2017. http://mohistory.org/exhibits/Fair/WF/HTML/Artifacts/olympics/image 2.html.

Missouri Women. "America's First Kindergarten." Accessed March 25, 2017. https://missouriwomen.org/2009/07/20/americas-first-kindergarten.

National Park Service, Heritage Documentation Programs—Historic American Buildings Survey/Historic American Engineering Record/Historic American Landscapes Survey (HABS, HAER, HALS). Accessed March 11, 2017. https://www.nps.gov/hdp/habs.

National Register of Historic Places. "Missouri. St. Louis County." Accessed February 23, 2017. http://nationalregisterofhistoricplaces.com/mo/st.+louis/vacant.html.

Nations Online Project. "Searchable Map and Satellite View of Saint Louis, Missouri." Accessed February 22, 23, 2017. www.nationsonline.org.

NextSTL. "The History of St. Louis Municipal Bath House." May 6, 2016. https://nextstl.com/2012/12/the-history-of-the-st-louis-municipal-bath-house.

Saint Louis Front Page. "Saint Louis Downtown Map." Accessed April 8, 2016. http://www.slfp.com/CityScapes.html.

Saint Louis Zoo. "Putting On a Show." Accessed March 14, 2017. https://www.stlzoo.org/about/history/puttingonashow.

Shapleigh Family Association, Shapleigh Hardware Company. "Shapleigh Hardware Company Saint Louis." Accessed February 21, 2017. http://shapleigh0.tripod.com/shapleighfamilyassociation/id13.html.

State Historical Society of Missouri's Historical Missourians. "Dred Scott." Accessed March 27, 2017. http://shsmo.org/historicmissourians/name/s/scottd/index.html.

St. Louis City Directories, 1821–77. "Edwards' Annual Directory to the Inhabitants, Institutions, Incorporated Companies, Business, Business Firms, Manufacturing Establishments, etc., in the City of Saint Louis." Accessed March 24, 2017. http://digital.wustl.edu/cgi/t/text/pageviewer.

St. Louis County Library. "St. Louis Business and Industry Bibliography—Architecture, Engineering, and Construction." Accessed February 23, 2017. http://www.slcl.org/content/st-louis-business-and-industry-bibliography-architecture-engineering-and-construction.

St. Louis County Place Names, 1928–1945. Accessed March 13, 2017. http://shsmo.org/manuscripts/ramsay/ramsay_saint_louis.html.

St. Louis Historic Preservation. "Mound City on the Mississippi, a St. Louis History." Accessed February 11 and February 23, 2017. http://stlcin.missouri.org/history/structdetail.cfm?Master_ID=2090.

———. "Mound City on the Mississippi, a St. Louis History—Structures." Accessed January 26, 2017. http://dynamic/stlouis-mo.gov/history/structdetail.cfm?Master_ID=1417.

St. Louis Police Veteran's Association. City of St. Louis Metropolitan Police Department. "Photo of Four Courts Building." Accessed January 19, 2017. http://www.slpva.com/historic/saintlouifourcourts.html.

———. "Saint Louis Police Headquarters." Accessed March 3, 2017. http://www.slpva.com/historic/saintlouispoliceheadquaters.html.

St. Louis Public Library. "St. Louis Streetcars." Accessed May 6, 2016. http://www.slpl.org/slpl/interests/article240137355.asp.

St. Louis Republic. "Famous Advertisement." May 21, 1905. Accessed April 8, 2015. http://chroniclingamerica.loc.gov/lccn/sn84020274/1905-05-21/ed-1/seq-15.

———. "Nugent's Advertisement." Sunday, May 21, 1905. Accessed February 25, 2017. http://chroniclingamerica.loc.gov/lccn/sn84020274/1905-05-21/ed-1/seq-3.

St. Louis Turns 250 in 2014. "The Rising Fourth City (1890–1904)." Accessed September 1, 2015. http://www.stl250.org/crash-course-fourth-city.aspx.

This D*mn House. "History Lost: The Buder Building." Accessed January 19, 2017. http://thisdmnhouse.blogspot.com/2008/09/history-lost-buder-building.html.

Toft, Carolyn Hewes. "Thomas Waryng Walsh (1826–1890)." Landmarks Association of St. Louis, Inc. Accessed January 26, 2017. http://www.landmarks-stl.org/architects/bio/thomas-warng-walsh-1826-1890.

University of Michigan Center for the History of Medicine. "The American Influenza Epidemic of 1918–1919: A Digital Encyclopedia." Accessed March 23, 2017. http://www.influenzaarchive.org/cities/city-stlouis.html#.

Virtual City Project. "The Old Laclede Hotel." Accessed February 2, 2017. http://www.umsl.edu/virtualstl/phase2/1950/buildings/lacledehotel.html.

Wanko, Andrew. "Turnverein History in St. Louis." In *The Glories of Germanhood: A History of the Turnverein in St. Louis*. Landmarks Association

of St. Louis. Accessed January 19, 2017. http://www.landmarks-stl.org/news/the_glories_of_germanhood_a_history_of_the_Turnverein_in_st._louis.

Wikipedia. "Architecture of St. Louis." Accessed September 4, 2015. https://en.wikipedia.org/wiki/Architecture_of_St._Louis.

———. "Streetcars in St. Louis." Accessed May 6, 2016. https://en.wikipedia.org/wiki/Streetcars_in_St._Louis.

———. "Streets of St. Louis." Accessed February 13, 2017. https://en.wikipedia.org/wiki/Streets_of_St._Louis.

Interviews & E-Mails

Rosen, Rick, Landmarks Association of St. Louis, volunteer coordinator. E-mails to the author, February 15, 2016.

Storm, Max, founder, 1904 World's Fair Society, Incorporated. Interview with the author, January 15, 2016.

Weil, Andrew, executive director, Landmarks Association of St. Louis. E-mails with the author, February 16, 2016.

INDEX

A

Academy of the Christian Brothers 117
Adams, Alvin 37
Adams Express 37
A.D. Brown's Hamilton-Brown & Company 41
Adolphus Meier House 55
A.F. Shapleigh Hardware Company 33
Ambassador Theater 65, 67
American Architect 59
American Brewing Company 34, 35, 144
American Hotel and American Theater Building 82
A. Moll Grocer Company 102
Anheuser Busch Brewing Association 92
anti-German sentiment 79
A.P. Erker & Bro. Opticians 35
Archdiocese of St. Louis 26

Astor, John Jacob 12
Audubon, John James 88
automobile 18, 94, 96, 97, 98
A.W. Fagin Building 33

B

Barnard Free Skin and Cancer Hospital 59
Barnard, George D. Residence 59
Barnes Hospital 110, 111
Barnes-Jewish Hospital 111
Barnes, Robert 110
Barnett, George I. 64, 83
Barnett, Haynes & Barnett 86
Barnum's Saint Louis Hotel 83
Bartold, Henry 83
Bartold's Grove 83
Basilica of Saint Louis, King of France 123
bathhouses 129
bear pits 79

Index

Beaumont Hospital Medical College 117
beer gardens 84
Belcher Sugar Refinery 35
Benton, Senator Thomas Hart 14
Bethlehem Lutheran Church 124
Blossom, Chalmers 56
Blossom House 56
Blow, Susan 115
B. Nugent & Bro. Dry Goods Establishment 104
Boatmen's Bank 36, 37, 89
Booth, Edwin 67, 73
brick 26, 27, 52
Broadway 31, 36
Brown Shoe Company 42
Buder Building, the 46
Buel, James W. 17, 139
Burlington Building 34
Busch, August A., Jr. 42
Busch Stadium 42, 67

C

Campbell House 60, 61
Campbell, Robert G. 60, 90
Carondelet 28, 115
Cassilly, Bob 106
caves 81, 84
Central High School 117
Central West End 56, 63, 64, 84, 94, 141
Century Building 37, 108, 143
Chamber of Commerce Building 134
Charles H. Peck Home 64
Charter Oak Stove and Range Company 62
Checkerdome, the 80
Cheltenham Syncline 29
Chimp Arena 80
Chinatown 42
cholera 15, 60
Chouteau, Auguste 9, 25, 52
Chouteau's Pond 14, 131
Cinerama theater 67
city hall 130
City Hospital 111, 112
City Museum 46, 107
Civil War 17, 50, 57, 60, 78, 82, 101, 119, 138
Clark, Charles P. 33
Clark, William 11
Clemens, Samuel 130
Coliseum, the 75, 76
Colonel Charles S. Hills House 57
Compton Heights 63
Conard, Howard L. 135, 140
Congregation Shaare Emeth 124
Cotton Belt Building 89
Cox, James 94
Cracker Castle 57
Crunden, F.M. 120
Curtiss, Glenn 96

D

Dacus, J.A., PhD 17
Darby, John Fletcher 11
Davis-Gaude House 30
DeBar's Grand Opera House 67
delivery boy 131, 132
Democratic National Convention 18, 45, 76, 141
department stores 102, 104, 105, 106

INDEX

Diamond Edge tools 33
Dickens, Charles 88
Dillard's 106
Diplomat Motel 84, 85
Dry, Camille N., and Richard J. Compton 9, 109, 111, 113
Drygoodsman and General Merchant, The 108, 141
dry goods stores 102, 105
dusters 96

E

Eads Bridge 28, 29, 51, 95, 99, 100
Eads, James B. 93
Eagle Stamps 105
Eames & Young 90, 121
Edward/Julius Walsh Home 58
Eliot, T.S. 9, 50
Equitable Building 51
Erker's Fine Eyewear 35
Excelsior Springs 35
Excelsior Stove Works 62

F

factory workers 41
Fairground Park 78
Fair of the St. Louis Agricultural and Mechanical Association 77
Famous-Barr 104, 105, 108
Famous Clothing Company 105
F.C. Taylor & Co. 40
Female Hospital, the 113
"filling" station 18, 96, 97, 105

First Congregational Church 125
First Methodist Episcopal Church 125
First Trinity Congregational Church 125
flatboats 93, 100
Flight Cage 71
flounder-style houses 53, 54
Forest Park 53, 63, 64, 69, 70, 80, 96, 101, 111, 120, 121
foundry workers 116
Four Courts Building 86, 131, 146
Fremont, Jesse Benton 14, 15
Friedman-Shelby International Shoe Company 39
Froebel, Friedrich 115
Funsten Brothers Fur Auction 40
furs 26, 28, 30, 40, 106

G

Gateway Arch 9, 13, 20, 21, 25, 30, 40, 46
Gateway Mall 46, 83
Gateway to the West 20, 29
Gemini 96
Gilbert, Cass 120
Giles Filley Home 60
goggles 96
Golden Age of St. Louis, the 17
Grand Central Terminal 98
Grand-Leader Stix, Baer & Fuller Dry Goods Co., The 106
Grand-Leader, The 106
Grand Opera House 67
Grand Republic 100
Grand Theater 67

Grant, U.S. 90
Gratiot Street Prison 119
Great Depression 56, 57, 59, 62, 63, 64, 92, 105
Great Divorce, the 17, 141

H

Hagen Theater 68
Hamilton-Brown Shoe Company 41
Hamilton-Brown Shoe Factories 41
hardtack crackers 57, 58
Havlin Theater 68
Hayward's Short-Hand, Type-Writing and Commercial College 118
hides 26, 30, 40
Historic American Buildings Survey (HABS) 54, 55, 56, 59, 83, 88, 90, 99, 141
Historic American Engineering Record (HAER) 99
Hop Alley 42
horseless carriages 96
Hyatt Regency St. Louis at the Arch 45
Hyde, William 135

I

Illinois River 10, 25
Inside Inn, the 70
Interstate 70 33, 101
Irving, Washington 12
Ittner, William B. 121, 144

J

Jack Daniel Distillery 43
Jack Daniel's whiskey 43
jail 85, 86
Jefferson Hotel 87
Jefferson National Expansion Memorial 20
Jefferson, Thomas 11
Jones Commercial College 118
Judge & Dolph Drug Company 43

K

Katz Drug Company 106
Kiel Auditorium 76
Kiel Center 80
Kiel, Henry W. 136
Kiener Plaza 86
King Louis IX 9, 25
Kingsbury Place 59, 60, 140
Kinloch Field 96
Knickerbocker Special, the 98

L

Laclede Hotel 85, 86, 146
Laclede, Pierre 9, 25, 52, 100
Laclede's Village 25
lamella roof 80
Landmarks Association of St. Louis, Inc. 18, 22, 141, 144, 146, 147
letter of introduction 136
Lewis, Merriwether 11
Liederkranz 69
limestone 12, 25, 26, 79, 81, 86, 87

INDEX

Lindbergh, Charles 44, 96
Lindell Hotel 82, 86, 131
Lindy Squared 44
Link and Rosenheim 121
Lion Gas Building 44
Locust Street 46, 60, 81, 96
Louisiana Purchase Exposition 11, 18, 46, 59, 69, 121, 130, 142
Louis Weidner's Beer and Wine Garden 84
"Love Song of J. Alfred Prufrock, The" 50
Lucas Place 29, 60, 62, 90, 117, 120, 121

M

Macy's 108
Marquette Building 37
Marquette Hotel 86, 87
Mauran, Russell & Garden 106, 133
Maxwell and Crouch Mule Company 133
McAdams, Clark 71
McCutcheon Road Bridge 98, 99, 142
McDowell, Dr. Joseph Nash 119
McDowell Medical College 119
Mercantile Library 107
Merchants' Exchange Building 45
Mercury 96
Mermod & Jaccard Jewelry Co. 46
Mermod Jaccard & King Jewelry Company 108
Mid-City Theater 75
Mill Creek Area 126, 127

Mississippi River 9, 11, 12, 15, 20, 25, 28, 30, 36, 40, 51, 52, 56, 62, 65, 78, 79, 81, 82, 93, 99, 100, 101, 113, 117, 130, 131, 133
Missouri Athletic Club 121
Missouri Botanical Garden 86
Missouri Daily Republic 67
Missouri Democrat 135
Missouri Gazette 26, 137
Missouri Pacific Railroad 46
Missouri Republican 137
Missouri River 9, 10, 25
Missouri State Highway Department 99
Moll, Adolph 103
morgue 131
Motlow, Lem 43
Mound City 10, 146
Mullanphy Park 133, 144
Mullanphy Savings Bank 47

N

narrow-gauge railroad 94
National Bank of Commerce 133
National Park Service 20, 145
National Railway Publication Company's *Official Guide of the Railways* 98
National Register of Historic Places 22, 37, 87, 122, 134, 145
National Register property 37, 67
National (Scott's) Hotel 87
National Stock Yards 133
National Trust for Historic Preservation 37
Native Americans 41

Index

New Cathedral 87
New Orleans 9, 20, 30
newsboys 48
newsies 48, 49
New York 9, 20, 30, 33, 37, 42, 44, 47, 77, 93, 96, 98, 118, 141, 142
1904 World's Fair 43, 59, 69, 85, 87, 120, 121, 130, 140, 145, 147
Nugent, B. & Bro. Dry Goods Establishment (Nugent Department Store) 104, 142

O

Observation Wheel 69
Old Cathedral 26, 30, 123
Old Courthouse 30, 125
Old Municipal Courts Building 131
Old Post Office 33, 37
Olive Street 35, 43, 50, 75, 101, 118, 133
Olympic Games 18, 46, 69
Olympic Theater 73

P

Palace of Fine Art Building 120
Peabody & Sterns 121
pelts 25, 28, 30, 41
Personal Reflections of John F. Darby 11, 139
Pevely Dairy Company 134
photography studios 135
Pickwick Theatre and Illuminated Garden 74

Pierce, Jonathan O. 57
Pike, the 11, 69
Pike, Zebulon 11
Pitzman, Julius 62, 63, 64
Planters' Building 89
Planters' Hotel 60, 88
Planters' House Hotel 82, 88, 89
police department 128, 131
Portland Place 62
Princess Theater 75
"private places" 53
privy vaults 128
Prohibition 35, 43, 79, 81, 83, 142
Prufrock-Litton Furniture Company 49, 50
Puck magazine 73
Pulitzer, Joseph 136, 138

Q

quarantines 112
"Queen of the Mississippi Valley" 94

R

railroads 39, 56, 62, 93
Railway Exchange Building 108
Rainbow Gardens 73
Ralston Purina 80
Rathskeller, the 83
raze craze 18, 30, 59
Red Cross Motor Corps 112
Red Crown Filling Station 100
Red Goose Shoes for Children 39
Republican National Convention 76

Index

Rialto Theater 75
riverboats 10, 56, 93, 94, 100, 133
Rockefeller, John D. 100
Roosevelt, Theodore 96
Rosebrough Monuments 50
Rosebrough, R.L. Sons' Marble and Granite Works 50

S

Saarinen, Eero 30
Sailboat Pond 86
Saint Louis Art Museum 71
Saint Louis Zoo 71, 79, 80, 145
saloons 84
Scott, Dred 30, 83, 145
Scottish Rite Cathedral 121
Scruggs, Vandervoort & Barney 105, 107, 108, 141
Seven-Up Company, the 23
Shapleigh, Augustus Frederick 33
Shaw, Henry 86
Shaw's Garden 86
Shoe & Leather Reporter 41
Shubert Theater 75
Social Evil Hospital 113
Southern Hotel, the 82, 90
Souvenirs of My Time 14, 139
Spaulding, Charles 73
Spirit of St. Louis 44, 96
Standard Oil 100
Starkloff, Dr. Max 112
Statler, Ellsworth Milton 70
St. Bridget of Erin Church 126
steamboats 12, 15, 16, 26, 93, 100, 118, 138
St. Francis Xavier Church 86
Stix, Baer & Fuller 105, 106, 143
St. Louis Arena, the 80
St. Louis Blues hockey 80
St. Louis Board of Education 121
St. Louis Browns 66
St. Louis Cardinals 42, 67
St. Louis Children's Hospital 113, 114
St. Louis City Jail 131
St. Louis Civil Courts Building 130
St. Louis Coliseum 75, 81
St. Louis Conservatory and School of the Arts (CASA) 125
St. Louis County 17, 18, 44, 94, 105, 125, 145, 146
St. Louis Dairy Company 51
St. Louis Day 69
St. Louis Exposition and Music Hall 75, 76
St. Louis Fairgrounds 77
St. Louis Globe-Democrat 86, 135
St. Louis Jockey Club 77
St. Louis Lambert International Airport 96
St. Louis levee 27, 51
St. Louis Life Insurance Company Building, 51
St. Louis Medical College 121
St. Louis Mutual Life Insurance Building 51, 143
St. Louis Perfectos 66
St. Louis Post-Dispatch 48, 87, 134, 136, 137, 138, 141, 142
St. Louis Public Library 119, 144, 146
St. Louis Republic 105, 118, 119, 135, 137, 146
St. Louis School and Museum of Fine Arts 120

INDEX

St. Louis Sugar Refining Company 36
St. Louis Turnverein 78
St. Luke's Hospital 110, 114
St. Nicholas Hotel 89, 90, 143
streetcars 101, 106, 146, 147
street grid 10
Sullivan, Louis 89
Sumner High School 115
Syndicate Trust Building 37, 108

T

Taft, William Howard 19
tax credits 18, 22
Taylor, Isaac 133, 134
Temple Israel 126, 127
Temple of Truth, the 135
terra cotta 29, 46, 87, 90, 106
Tony Faust's Oyster House and Restaurant 91
Tower Grove Park 86
trolleys 101
Tully & Clark 59
Turners' Hall 78
Twain, Mark 130

U

Uhrig's Cave 75, 81
Union Station 14, 33, 93, 98
University City 103
University Club 58
urban flight 18

V

Vandeventer Place 59, 62, 63, 64
Victoria Building 89, 90

W

Walsh, Thomas 86
Walsh, Thomas W. 131
Washington Avenue 33, 36, 39, 42, 81, 86, 87, 104, 106, 107, 108, 114, 118, 121
Washington Terrace 63
Washington University 114, 120, 121
Washington University's School of Medicine 114
water 15, 130
watering troughs 128
Wellston Loop Building 106, 107
Westliche Post 136, 137, 138
Westmoreland Place 64
William Barr Dry Goods Company 105, 108
wooden barrels 138
World War I 79, 89
World War II 18, 63, 79, 99

ABOUT THE AUTHOR

Valerie Battle Kienzle is a native of Nashville, Tennessee. She is a graduate of the University of Missouri's School of Journalism in Columbia. She spent the last thirty-five-plus years employed in various writing-related positions: newspaper reporter, corporate public affairs manager, advertising account representative, school district communications writer, freelance writer and author. She has written two books for Arcadia Publishing, *St. Charles* (2012) and *Columbia* (2014), and one book for Reedy Press, *What's with St. Louis?* (2016).

Valerie is a member of the Society of Children's Book Writers & Illustrators (SCBWI), the State Historical Society of Missouri and the St. Charles (MO) County Historical Society. Her interests include reading (history, nonfiction), music (all genres), gardening, travel and genealogical research. An animal lover, she and her husband share their St. Louis–area home with a dog and a cat.

Valerie credits her grandmothers with instilling in her a lifelong love of history. The stories and photographs they shared made her want to learn more about the past. She, her mother and brother share ownership of Beech Hill Farm, a National Register property owned by family members since 1796.

Visit us at
www.historypress.net